To Susan + Alan
Best wishes
Joanne Beighford

Montana
Hometown Rodeo

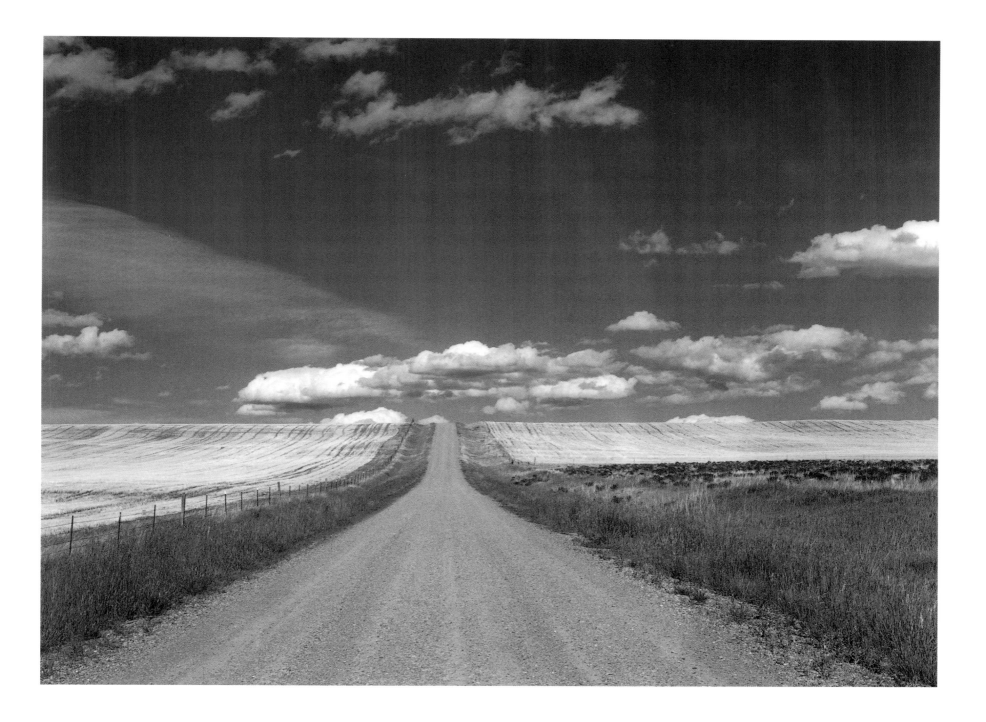

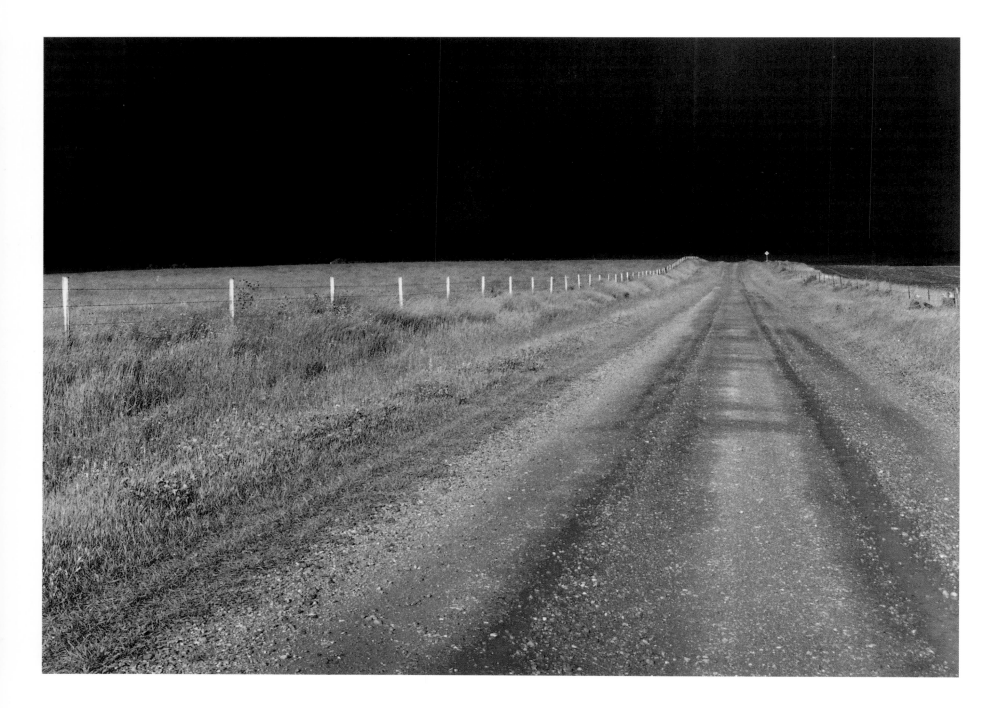

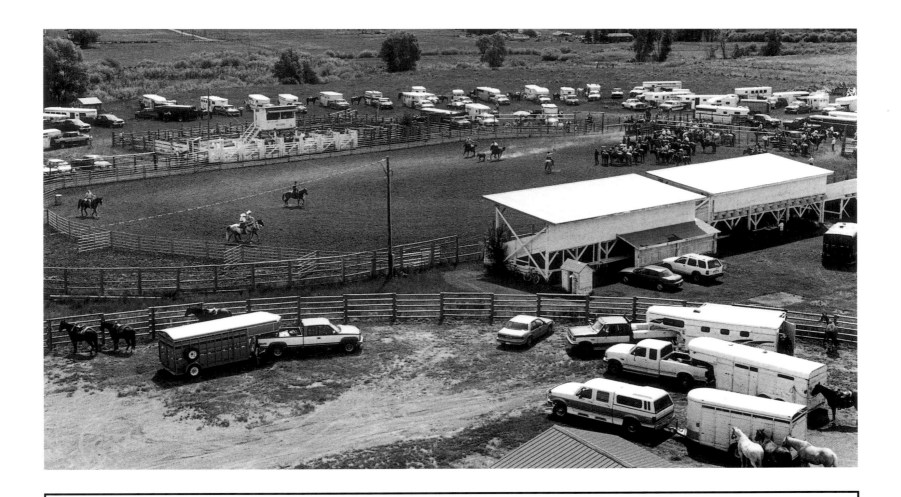

Montana
Hometown Rodeo

Photographs by Joanne Berghold
With an Introduction by Kim Zupan

Museum of New Mexico Press, Santa Fe
in association with the Center for American Places

For Billy

This book was developed by the Center for American Places (P.O. Box 23225, Santa Fe, NM 87502, www.americanplaces.org), in collaboration with the Museum of New Mexico Press.

The photographs for *Montana Hometown Rodeo* were taken during the period 1990–2001.

Project editor: Mary Wachs
Design and Production: David Skolkin
Manufactured in China
10 9 8 7 6 5 4 3 2 1
Library of Congress Cataloging-in-Publication Data
 Berghold, Joanne.
 Montana hometown rodeo / photographs by Joanne Berghold ; with an introduction by Kim Zupan.
 p. cm.
 ISBN 0-89013-469-3 (Clothbound : alk. paper)—ISBN 0-89013-470-7 (Paperbound : alk. paper)
 1. Rodeos—Montana. 2. Rodeos—Montana—Pictorial works. I. Title.
 GV1834.55.M9B47 2004
 791.8'4'09786—dc22
 2003019829

Museum of New Mexico Press
Post Office Box 2087
Santa Fe, New Mexico 87504

Contents

ix Acknowledgments

xi Preface

1 Introduction by Kim Zupan

7 Plates

108 Photographic Credits

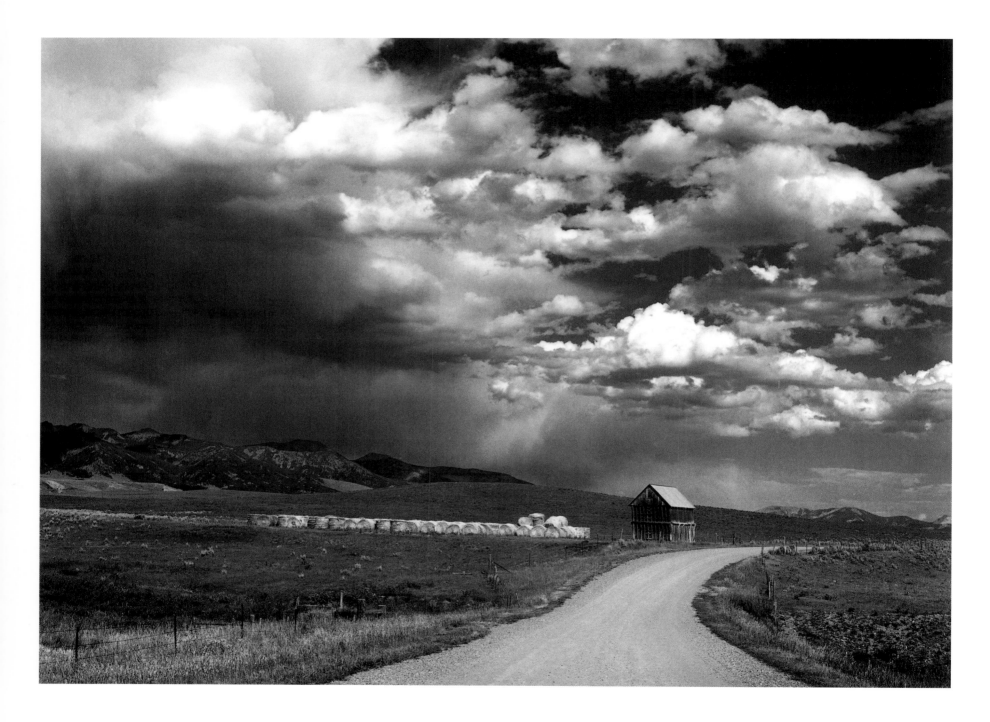

Acknowledgments

As I started this book, I was not aware of how much time, work, and patience would go into its creation. It has been a long, rewarding, and exciting project for me. Although I name only a few, I will be forever grateful for the support of many individuals whose help, both actual and spiritual, was critical.

I am grateful to photographers Sean Kernan and Ralph Weiss, who taught me how to "see." Many, many thanks to my dear photography friends Barbara Remnitz, Maureen Gleason-Shreve, Seena Sussman, and Jane Vollers, who were so generous with their time as they tirelessly helped me edit images over the years. Thanks also to Deb Clow, Nancy Elghanayan, Igor Gordevitch, Leslie Lee, Carole Obedin, Carrie Seglin, Kim Schmidt, Nancy Tanner, and Christopher Young. I am truly appreciative of their support and advice. Allen Jones, Jonathan Doelger, Dee Ratterree, and Mary Wachs shared my vision of the project early on, and Mary Wachs made it a reality, and I am forever grateful to them.

Jim, Elaine, and JimBo Logan opened their ranching hearts to me, and young Robert and Rachel VanderVort showed me what hard work and practice can do for aspiring

rodeo contestants. Dozens of Northern Rodeo Association members, especially Tootie Rasmussen, and residents of small towns and various ranches, were friendly, helpful, and accepting, and I thank the many unnamed.

My deep gratitude to George Thompson and Randy Jones from the Center for American Places for believing in the book, suggesting additional images to illustrate the rodeo story, and helping bring the project from concept to reality.

I am grateful to my parents, Mimi and Billy Meehan, who introduced me to the West. I am extremely happy that my grown children, Mark, David, and Kara, also share my love of Montana. Kids often know best—without their strong encouragement and unwavering support, the computer would still be a mystery.

Last but not least, my deepest thanks to Billy, my resident editor, friend, and supportive husband, whose selflessness freed me to spend long summer months following the rodeos and equally long winter months in the darkroom.

Preface

BORN AND RAISED A THOROUGHLY URBANIZED NEW YORK CITY GIRL, I was first introduced to rodeo in 1951, at Madison Square Garden, when I was eleven. The sport immediately fascinated me, and I became intrigued with cowboys, horses, the simple outdoor lifestyle, and all things western. From my city home, I even collected 45 rpm records of the day's most popular "cowboy" singers, such as Gene Autry and Roy Rogers, and eagerly awaited the rodeo's annual return.

When my family decided to make a trip west in 1954, I was thrilled. Our travels took us to Yellowstone National Park, the Grand Tetons, Cody, and Jackson Hole. We then spent a few weeks at Eatons' Ranch, the oldest dude ranch in the country, at the base of the Bighorn Mountains, in Wolf, Wyoming, near Sheridan. There, at the weekly ranch rodeo, I first experienced the sport in its proper western context. From Eatons', we drove six long hours to Cheyenne to attend a rodeo known as "the granddaddy of them all," at the local Frontier Days celebration. I loved horses, so the bareback and saddle bronc events were my favorites, watching the majestic, beautiful, muscular animals and the way they moved.

That summer changed me forever. I fell in love with the West, and when I returned home, was all too ready to trade city parks and pavement for dirt trails and corrals, the Atlantic shoreline for the Rockies and Great Plains. A new world had opened up for me, and I longed to return, perhaps to work a summer at a dude ranch. However, fearing I would move west and marry a cowboy, my parents wouldn't hear of it.

Years later, I was delighted when two of my three children landed summer jobs at dude ranches. (My third child now resides in Montana.) During the 1970s and 1980s, my husband and I made several trips to those ranches, where I reimmersed myself in the West. Then, in 1989 I happily realized my lifelong dream of becoming a westerner, when we bought land and built a small log home in southwestern Montana, at the edge of the Crazy Mountains. Initially I had planned to live there only during summers, but gradually summers have expanded to half-year residency, and I find it increasingly more difficult to return back East.

In the early years of our Montana stays, I packed a camera and drove around in my truck exploring and trying to capture on film the landscape of the state in which I felt so at home. I had studied photography in college and been photographing since 1980. During one of those initial summers, I shot my first rodeo as a favor to a friend, Don Vaniman, who was an organizer of the local sheep and wool festival. A photographer originally hired to cover the Bozeman event had canceled at the last minute. Having photographed ranch horses for the past decade, and exhibited and sold prints of some of this work back East, I jumped at the opportunity to learn more about rodeo and to photograph the interactions between animals and humans.

The next ten years were an amazing adventure as I became more and more involved in photographing the rodeo experience. Each summer I crisscrossed Montana visiting the predominantly agricultural and ranching towns of Boulder, Belt, Wilsall, Roundup, Deer Lodge, Three Forks, and Big Timber, among many others.

Initially I worked to capture the best image, both from documentary and aesthetic standpoints, of each event. With the development of a book project, I sought to reveal a

fuller story by showing what goes on behind the scenes. In the process, I learned not only about the many proscribed rodeo events but also about the motives and passions of small-town rodeo participants. What I thought was just a sport turned out to be a way of life.

I had grown up in a world in which parents' and children's activities shared little common ground. We met at the dinner table and talked about our separate day's experiences. By contrast, in most of the Montana ranching and rodeo families I've met, everyone pulls together for a mutual goal, especially around rodeo. Mothers, grandmothers, and children work the ticket booths and run the concession stands. A grandfather may team-rope with a grandson or granddaughter, while a mother coaches her daughters in barrel racing and a teenage boy helps his little brother ride a sheep in preparation for handling a calf, horse, or bull in later years. Parents teach their children not only how to be good winners, but also good losers. Learning comes from doing, and children share with their parents the rodeo tradition, derived from both the work and the land.

At friend Jim Logan's arena in Clyde Park, four generations gather to watch, critique, and encourage family and neighbors in honing their skills. Occasionally I'll bring some visiting eastern friends, who are as delighted to gain a close-up look at rodeo's roots as I was that first summer at Eatons' Ranch.

Despite the warm welcome I always receive in my adoptive home and in the places to which I travel, I occasionally still feel like an outsider, an easterner who feels deeply at home in the West but remains city-born. I continue to ask questions and am always learning about rodeo and its events. Much of my time is spent behind the chutes, where the cowboys display a great camaraderie while intently focused on their respective rides. One senses their eagerness and excitement, along with palpable jitters, as they await their turns. Politely they respond to my questions in their laconic western way—"yes, ma'am," "no, ma'am."

By now, I have watched little boys grow up to be bull and bareback riders and little girls become expert barrel racers and ropers. I've visited with many of the same families

over the years of shooting and have made a number of lasting friends. And there are those extraordinary times when I do feel part of the community—as when one of the bullfighters at the beginning of a season welcomed me with a big smile and an even bigger hug, or when a steer wrestler's wife gave me a denim shirt inscribed with the words "Number One Photographer."

Seeing and hearing families and friends cheer on their riders, I admire the spirit of small-town rodeos. Ranchers and townspeople working and playing, competing and celebrating, is something to be cherished. But, regrettably, such local rodeos are changing and slowly passing away. I am saddened to think that the traditional sport may be one day lost to commercial interests. Economics have forced so many small ranchers to sell to larger ones, to developers, or to wealthy out-of-state folks interested in the locale but not the life. Some ranchers now divide their time between ranching and working second and third jobs to make ends meet, as the economy forces them to reduce their herds.

Increasingly, hometown rodeos are no longer *truly* local, at least not as they were twenty-five years ago. In the past, most local-rodeo participants knew one another; today, the majority of contestants come from other places, even Canada, in their quest to break into the amateur or professional rodeo circuit for prize money. Moreover, many live and work in nonranching areas and may earn their living in careers unrelated to the land itself. Even the towns themselves grapple with economics, as they struggle to maintain the tradition of staging a rodeo-day parade.

In a sense, local rodeos have fallen victim to the event's exploding popularity, as professional rodeo is one of the fastest-growing spectator sports in America. Not surprisingly, it has become heavily commercialized, giving rise to the glitz associated with national sponsors for cars and beer and western wear instead of the local family-run businesses operating concession stands and raising money for local charities and small-town advertisers selling grain, tack, and construction materials.

With the publication of this book, maybe I will put down my camera and be content just to sit high in the bleachers and cheer with the others at the next hometown rodeo I attend. Perhaps I will wander around the chutes and crow's nest, and visit with friends. I do know that when I hear the National Anthem and watch the cowboys and cowgirls line up in the arena with their hats on their hearts, or when the announcer opens with "A Cowboy's Prayer," I will be moved not only by patriotism but also by feeling the sheer smallness of it all, the authenticity and genuine spirit that comes from watching people do what they love out of celebration, not professionalism, and celebrating a tradition that springs from their lives as ranchers and westerners.

It has been a wonderful, incredibly exciting experience photographing Montana's hometown rodeos and those connected with them. These people's lives cannot be separated from the dramatically beautiful land and harsh climate in which they work and play. I admire them and sincerely hope this book contributes to an awareness of and appreciation for the small-town roots of this important and much-loved American tradition.

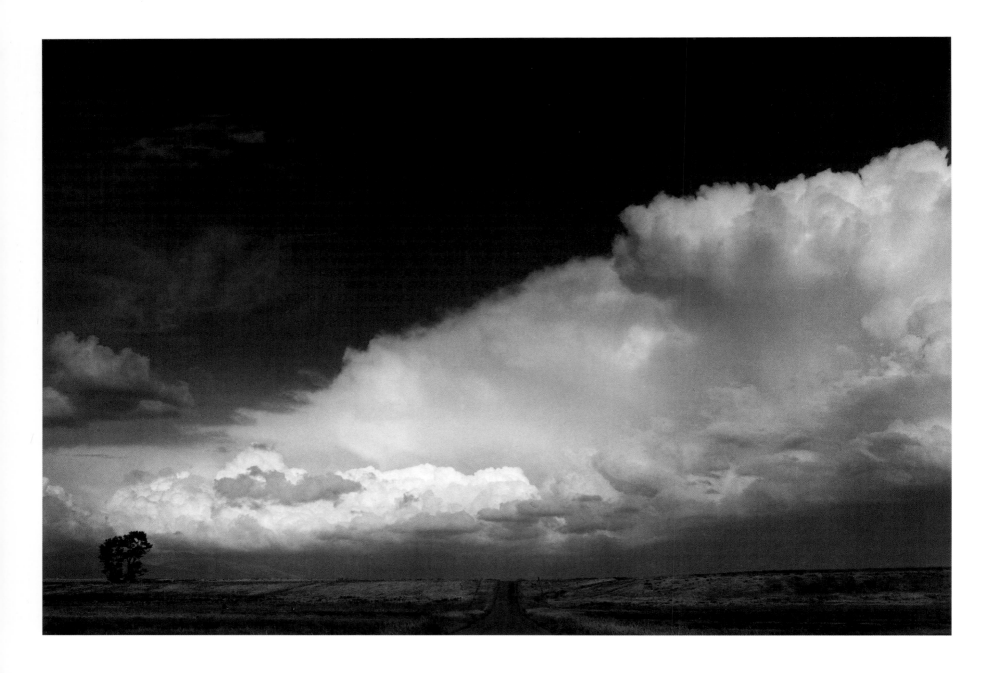

Introduction

By Kim Zupan

SEEMINGLY ANOTHER LIFETIME AGO, the rodeo was so small, so remote, its time and location were something like rumor. Or myth. The news seemed to float out over the country like pollen, infecting with horse dreams young men and women sitting atop their tractor seats, ratcheting stubborn bolts in the cool fug of a Quonset, or making glassy-eyed the girl staring down a vacant street from behind a luncheonette counter.

Word filters in. No garish posters announce its time and venue, no slick DJs riff ten-second radio spots. At the saddle shop where I hang around just to be close to tack, the smell of leather, the cousin of a friend of a friend speaks the name of a town I've never heard of. I call information, wheedle and cajole several strangers, until at last I connect with the rodeo's secretary, a weary ranch wife I envision scribbling my odd name on a pad cocked among the remnants of a meal.

From Great Falls I head dead north, across fissured mudflats clotted with tumbleweeds, past grain elevators whose roof tin woggles loose in the wind. I pass the Missouri where

it embraces Fort Benton in its great taciturn loop, roar down into the Marias bottom-land, where debauched pink cottages squat among cottonwood boles, long dead and bone white, along the muddied bank. Beyond, the Bear Paws suddenly loom. Far to the northwest appear the Sweet Grass Hills—to a stranger got here by grave mistake, they might seem a thunderhead rolling down from the Alberta prairie. From this bleak sage ground in all directions, blued ranges loom like promises: The Rockies' crenellated line in the west. The round, weathered domes of the Highwoods and Little Belts to the south and east. It was here, at Rocky Boy, the Chippewa Crees were exiled from their ageless wanderings.

The cow town of Big Sandy is seventy-one miles out, on the western end of the Bear Paw Mountains, and turning here, bearing east into a merciless sun, I traverse thirty-two miles more of tortuous gravel to get to the Town That Is Not a Town, but merely a Place. The first few miles out there are signs of a human presence: drooped four-wire fence, a ranch house set back in a bare gulch. I pass a natural-gas pumping station (unmanned), a windmill on its oxidized stilts, fallen blades ashimmer in the dirt beneath like autumn leaves. A power line disappears over a rocky tumulus. Then nothing. A calving shed, openness. Emptiness.

Propelled by hearsay and hope, I drive for an uncomfortable hour and feel both relief and unease when I arrive at last at a barren flat that goes by the name of a town. I see stock, vague phantasms beyond a drapery of dust, and an arena cobbled up as if by whim, an ellipsoid of mismatched posts and sheep wire enclosing dirt scarcely tilled and peppered with rocks.

Shortly from the vacancy people begin to materialize like ghosts of all the ancient Chippewa. The rude arena is circled with dusty cars, nosed into the wire like cattle at a stock tank—Buicks and Cadillacs, scraped and dented pickups and flatbeds with fencing gear still strewn on the boards. As if beset by locusts, the air hums with conversation. Penned bulls moan and roar. The bucking horses in their enclosure call out to the freedom of the vacant hillsides.

They call them "punkin rollins" or "jackpot rodeos," and beyond the dizzying occasional basketball championship or Fourth of July picnic they have been the primary celebration of small towns in the West for more than a century. Ranchers and farmers, sprung for a day from their endless work, come to forget the woeful price of cattle or grain, the paucity of hay, the busted baler. In a largely solitary life, where the idea of a neighbor is no more than a single halogen burning in the great dark distance, it is a time to come together in a place beyond work. A day to lean on the fence, drink a beer, admire the slope of a quarter-horse haunch. A once-a-year pilgrimage down from the hills and gulches of their solitude to solemnize a way of life.

The genesis of rodeo is at least as old as the Minoans, those long-dead Mediterraneans who formed a kind of religion around bull-vaulting, wherein men and women clasped the horns of rampaging bulls and somersaulted onto the animal's back.

That almost-religious fervor remains among cowboys for their sport, but rodeo as we know it today is a transmutation of the work early cowmen did to earn their daily bread. After the horrors of the War Between the States, young veterans and freed slaves drifted into the unbridled expanse of the West and began to gather feral cattle descended from the abandoned herds of early, luckless Spaniards. They drove them to Kansas and Missouri railheads, where they would be shipped east to supply a growing population with a yen for meat. At these Midwest terminuses in the 1880s, cowboys from rival drover outfits celebrated their emancipation from months of dust, heat, floods, and cold by holding riding and roping contests. With the advent of barbed wire and the incursion of railroad lines deeper into the great empty hills and plains, the life of the nomadic cowboy was all but extinct, yet the urge to out-rope a top hand or ride down the rankest bronc remained. Soon, organized annual rodeos began to appear in such places as Deer Trail, Colorado; Prescott, Arizona; and Alpine, Texas. Wild West shows sprung up as the dime-novel myth of the cowboy swept eastward across the country, traversing even the gray Atlantic to the staid shores of Europe. Men took their trade under the big

top, and chores that had been drudgery on the cattle trail now astonished crowds in Paris—twirling loops and fanning broncs became showbiz. Only steer wrestling seems to have been invented for sheer entertainment value. A black cowhand named Bill Pickett contrived to throw steers by twisting their necks and biting their lips, imitating the crazed bulldogs he'd seen hazing cattle on open range.

True athletes from every corner of the country populate the arenas in modern rodeo; former wrestlers and college football players compete side by side with kids from remote ranches and inner cities. Bulls and timed-event cattle and horses are grained and pampered, quadruped gladiators valued like children by contractor and contestant alike.

Rodeos in such places as Houston and Calgary and Cheyenne adorn their events with pomp and ephemera, Day-Glo color and glitz. Pep bands honk and blare while doggers wrestle cattle and ropers jerk their slack; lights dim at night between events, and country singers croon in a pool of spotlight. I've seen monkeys in gauchos' hats herd sheep while strapped to the backs of dogs, and more than once I've wanted to set free a trained buffalo, taught to balance his carpeted bulk on a teeter-totter and a ball like a circus pachyderm.

But the one constant at the heart of even the gaudiest shows is that of man-against-nature, and its purest evocation remains in small rodeos. In the town that was not a town I found those years ago; there were not even bleachers. Spectators sat on the hoods of their cars or in the scant shade of the broiling interior, honking their horns in lieu of clapping. Children hung from the sheep wire of the arena fence like pygmy scarecrows, inhaling the dust of passing livestock and dreaming their roughstock dreams. A single power line looped across blank prairie to fuel the sole concession stand and announcer's crow's nest, from which a rusted PA trumpet blatted a garbled voice. No chemical toilets, but a two-holer teetering above a trench. No bunting and no music, save the sound of jangling tack. No advertisements adorning each chute gate. Small-town rodeo: just men and women coming to ride and folks coming to watch.

I was a kid then. I parked my Dodge and wandered around woodenly with my war bag. I hunted up the stock list and found my name beside my draw, a gaunt-hipped bay with a name like Death Trip or Widow-Maker. I unpacked my gear, stretched, listened to my heartbeat above the banging of hooves and clanging shut of slide gates, as horses were run in. I carried my riggin to the chute, and a young Cree kid hooked my D ring, set the rig loosely, and hung around to give me a final pull. My bronc in his dusty box rolled back a goggling eye. I remember at that instant—and it happened every time, at every rodeo, even after I graduated to so-called bigger and better shows—my world suddenly diminished to that three-by-eight box wherein stood a horse. Me. The horse. City, small town, or no town whatever, it came down to this.

Some twenty years later, having a rare day to kill and taken by a vague, strange unease, I retrace that route I'd traveled with my trunkful of bucking horses' dreams. I drive through the greening hills of April and finally, under a pure blue dome of sky, stop on the county road and stare bleakly at the place. It's clear the rodeo has not been held in years. Like the ribs of a beached trawler, the bleached and split posts and poles of the arena lie about in the sage and thin grass. It is not a ghost town, as there had never been industry or population to have gone under or passed on, but a ghost rodeo.

I maunder about with my head down, kicking the dirt. There is not a sigh of wind or even birdcall. It is the silence of empty country that I love, but now it only intensifies the whole funereal feel of the place. Chokecherry grows in the rotting bucking chutes, woven like basketry among the split gate slats, and the sheep wire is a rusted snarl among weed stems, dully aglow in the spring sunlight. Concession stand and announcer's booth have fallen in, and gray-white lumber bristling with nails cascades down the small raw knob like the bones of Custer's horses.

To be sure, I miss the thrill of that eight-second jolting flight and perhaps as much the simplicity of a time when all in the world that mattered was horses that bucked. I've come here to revisit the single-minded, exuberant kid I once was and find this hallowed

site all but reclaimed by nature, as if someone conspired to rob me of time, of memory. I walk the grounds, try to imagine a day filled with noise and excitement and possibility. Here there is only silence and a vague feeling of sadness. I go to the car and drive away. It is as though the ground has been sown with lime.

Had I known of Joanne Berghold's photographs, I might have saved myself that tormented revisitation. The blood thrum of small-town rodeo is preserved in every starkly beautiful image, evoking the scent of penned horses and sage crushed under the tires of trucks, the roar of bulls battering loading chutes with their blunted horns, the squawk of rosined leather. And over it all like an electric hum the gabble of hardworking people taking their rare ease. Montana's prairie may have taken back the site so rich in my memory, but I owe Joanne Berghold a great thanks. A vital slice of our collective history gleams bright in the face of a child aboard a sheep, in the rolling eye of a bronc. And through these lovingly captured pictures, I realize, to my great happiness, that not very much at all in this grand sport has changed since old Bill Pickett first bit that steer's lip.

Montana
Hometown Rodeo

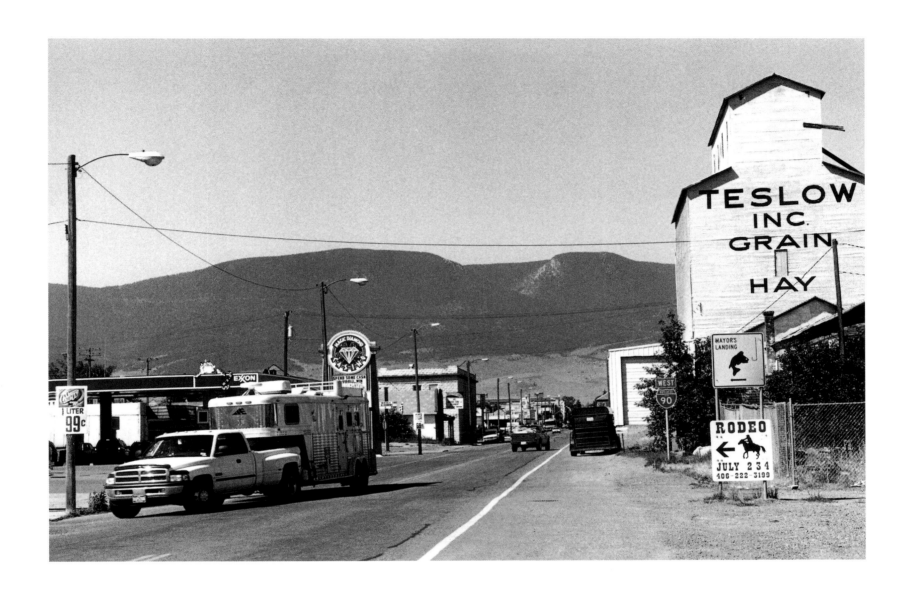

1. Rodeo Weekend, Livingston

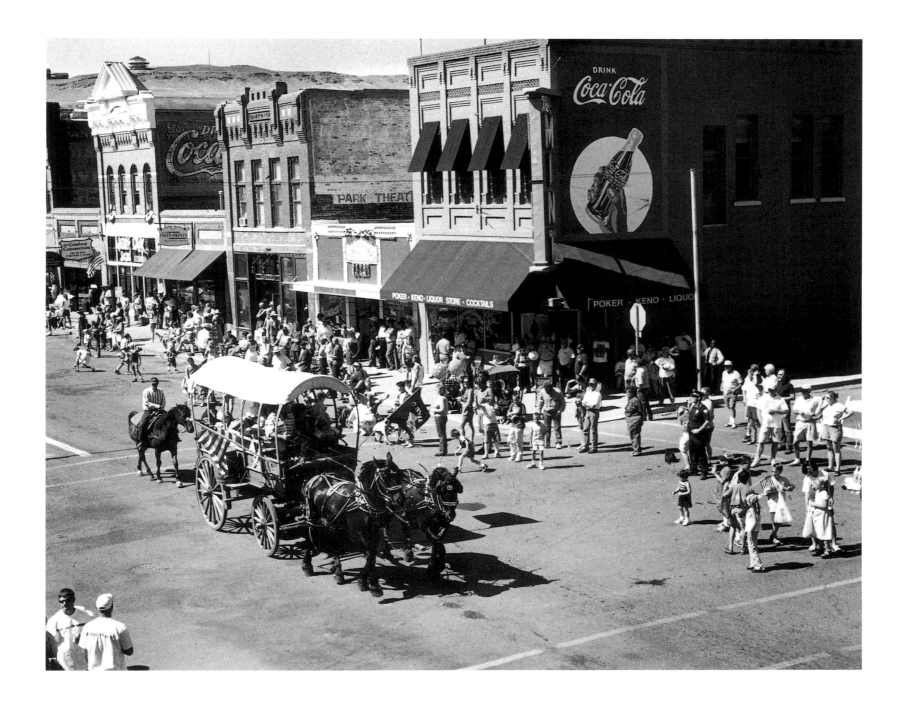

2. Livingston Parade—Main Street

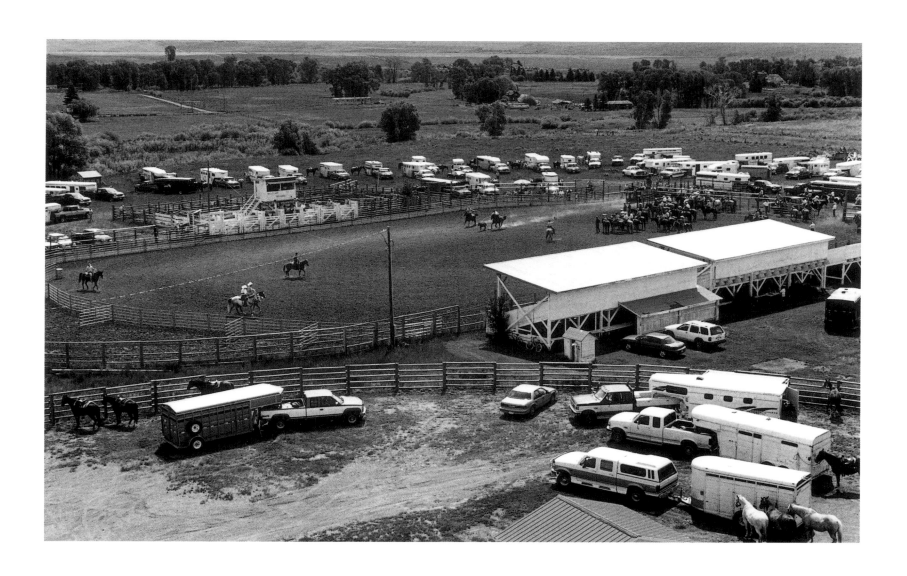

3. Team Roping Event, Wilsall Rodeo Grounds

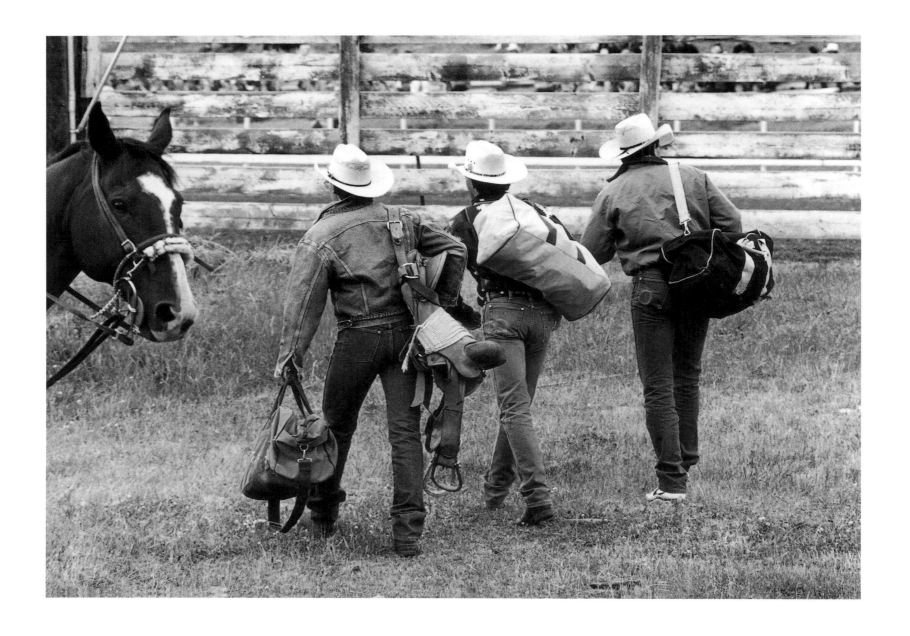

4. Cowboys and Their Gear Bags, Augusta

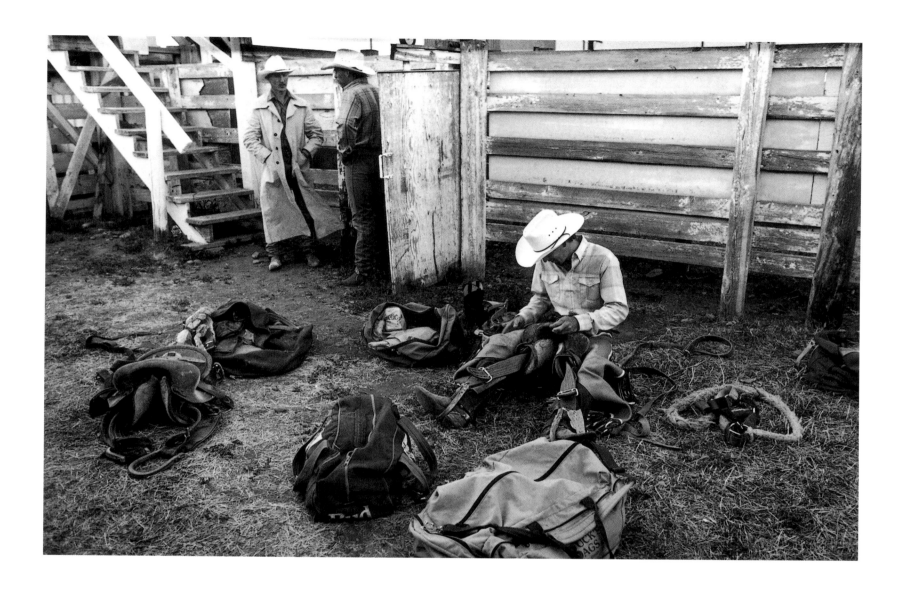

5. Checking the Saddle for the Next Ride, Livingston

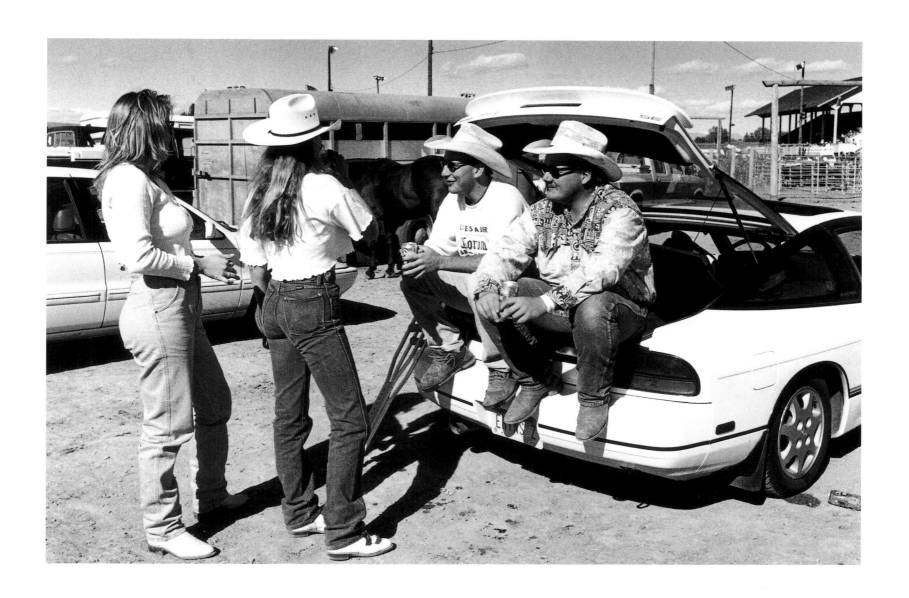

6. Waiting for the Rodeo to Begin, Dillon

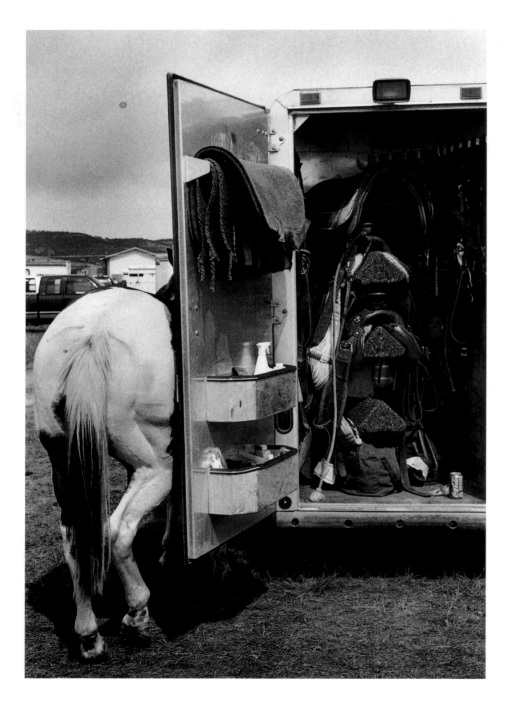

7. Resting Between Events, White Sulphur Springs

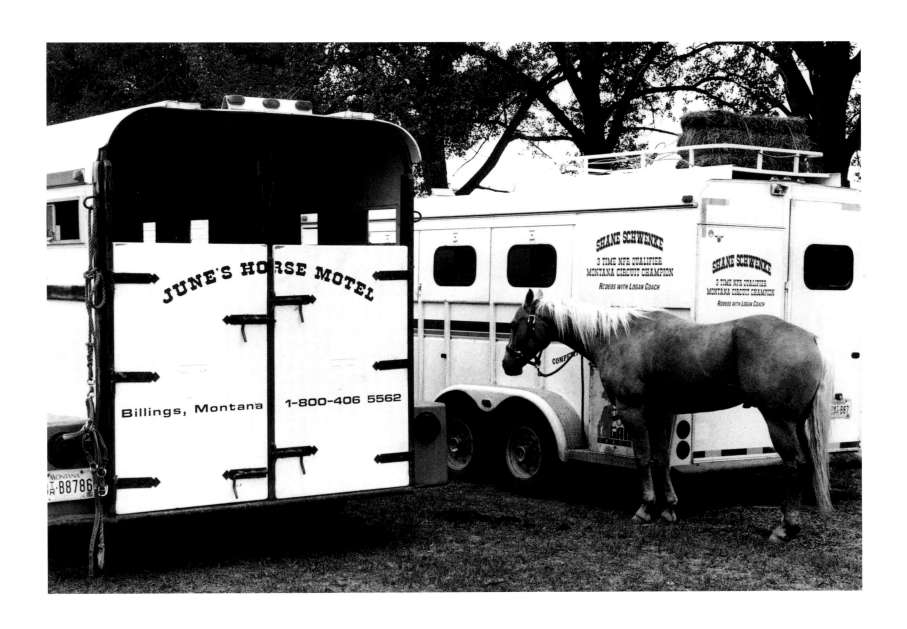

8. Horse Trailers, Big Timber

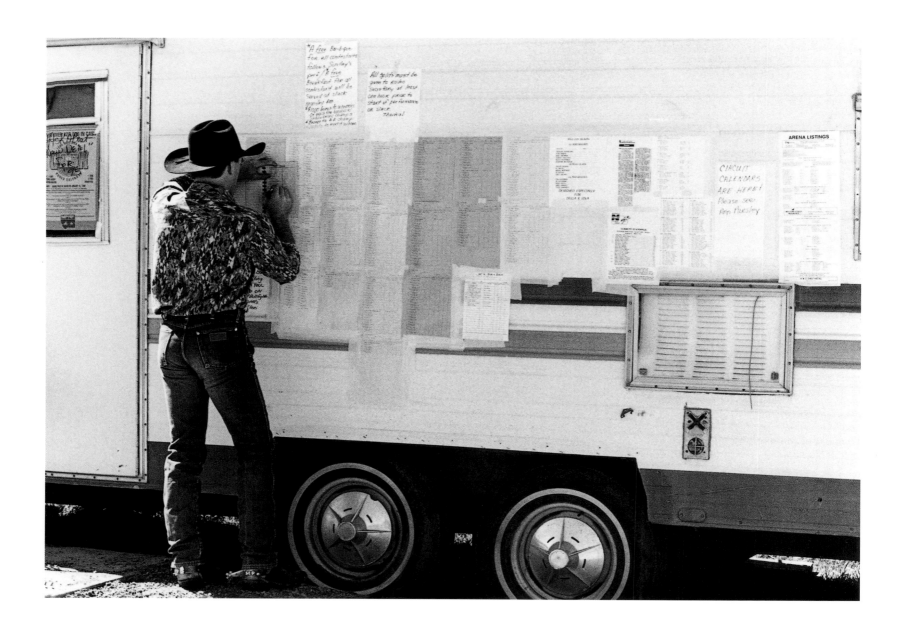

9. Cowboy Checking the Draw, Dillon

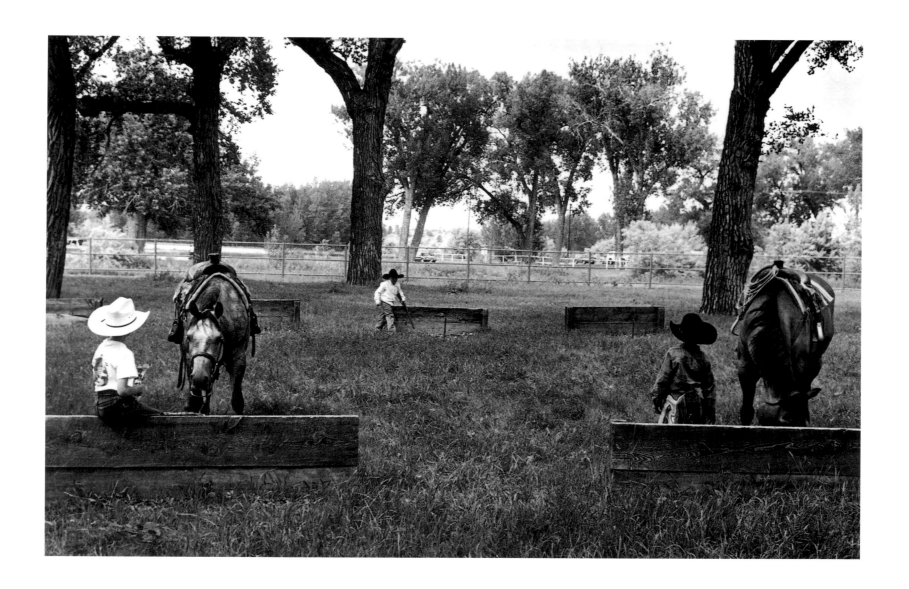

10. Young Cowboys, Roundup

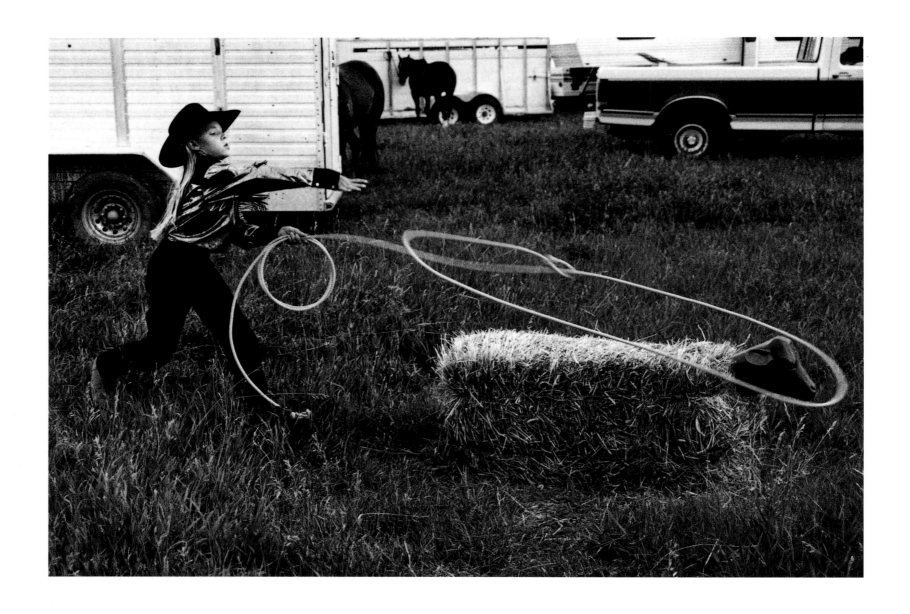

11. Young Cowgirl Practicing Roping, Townsend

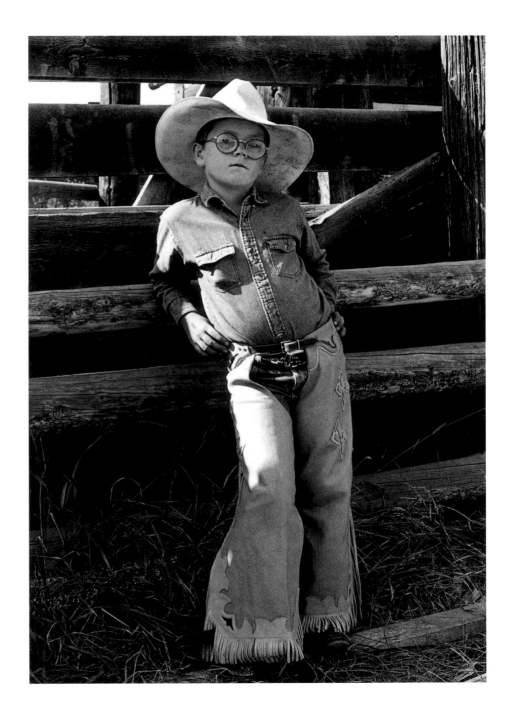

12. Young Cowboy, Boulder

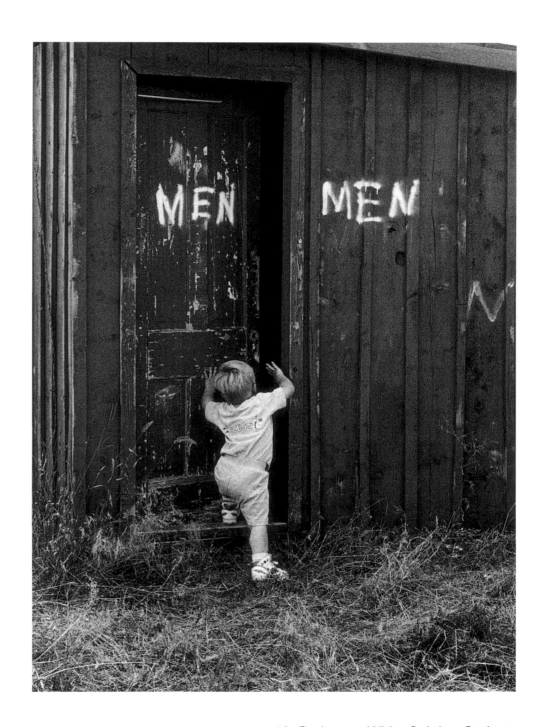

13. Outhouse, White Sulphur Springs

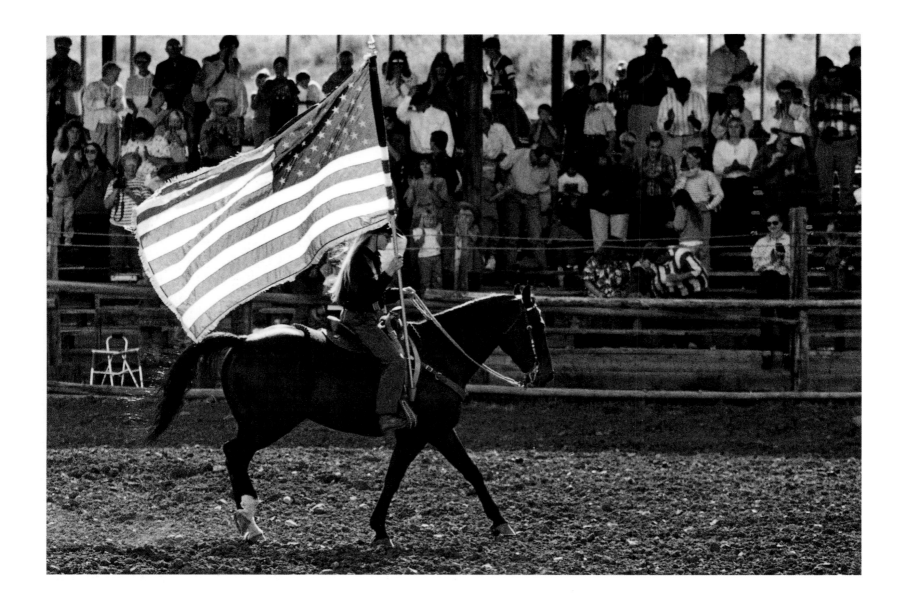

14. Presenting Old Glory

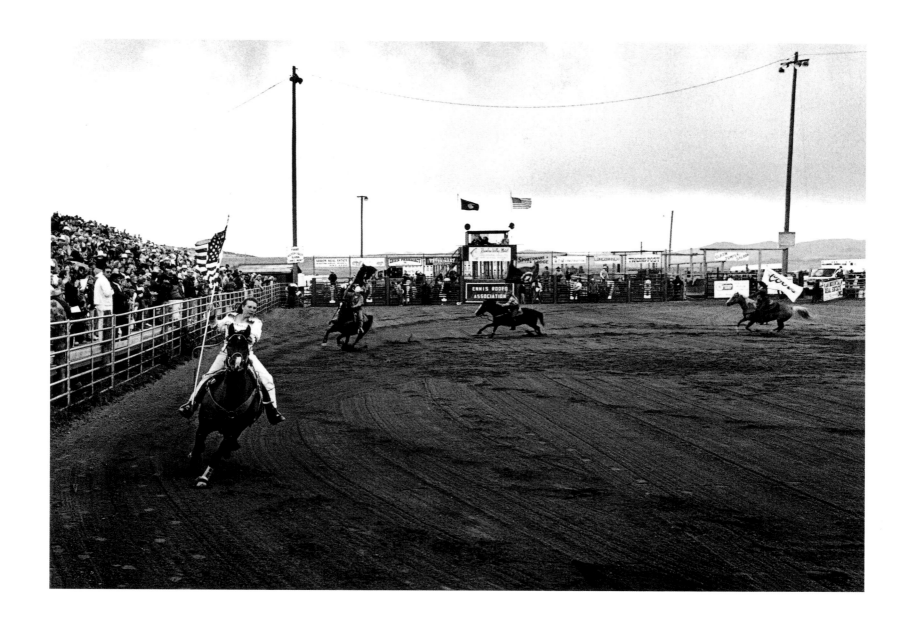

15. Grand Entry, Ennis

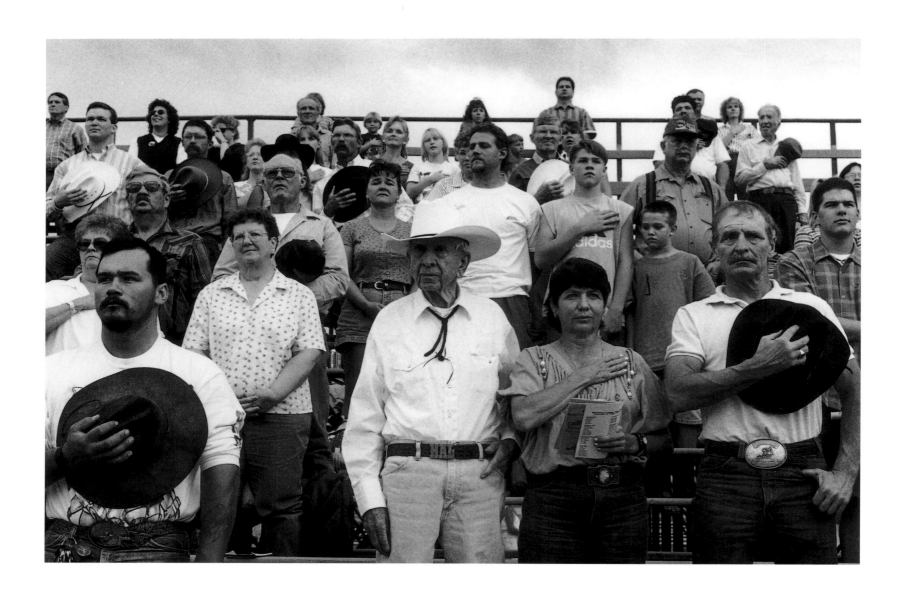

16. Fans' Pledge of Allegiance, Bozeman

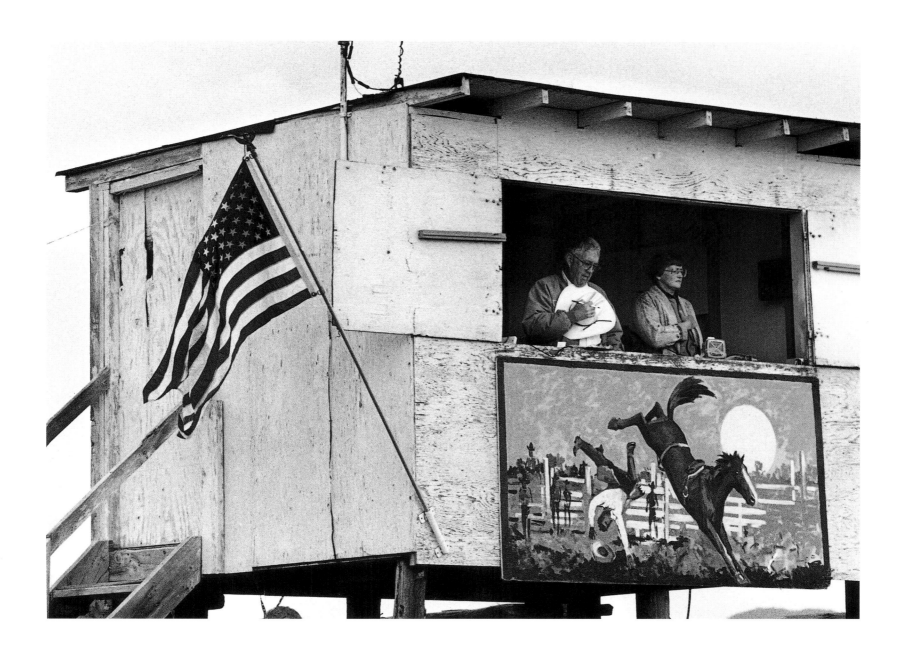

17. The Crow's Nest, White Sulphur Springs

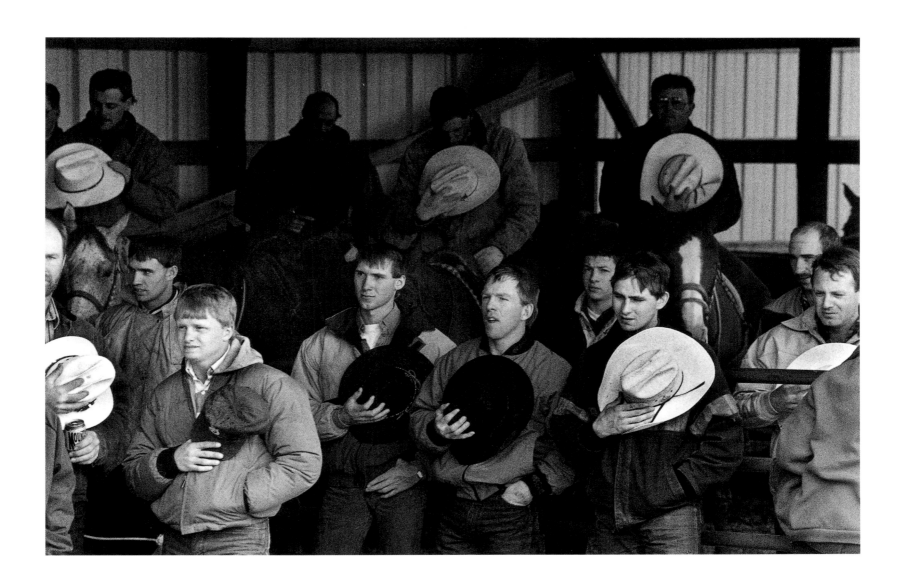

18. Cowboys' Pledge of Allegiance, Harlowton

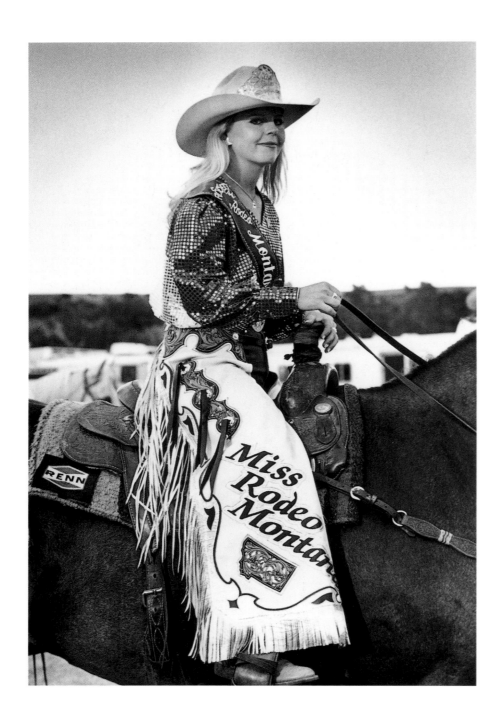

19. Miss Rodeo Montana, Livingston

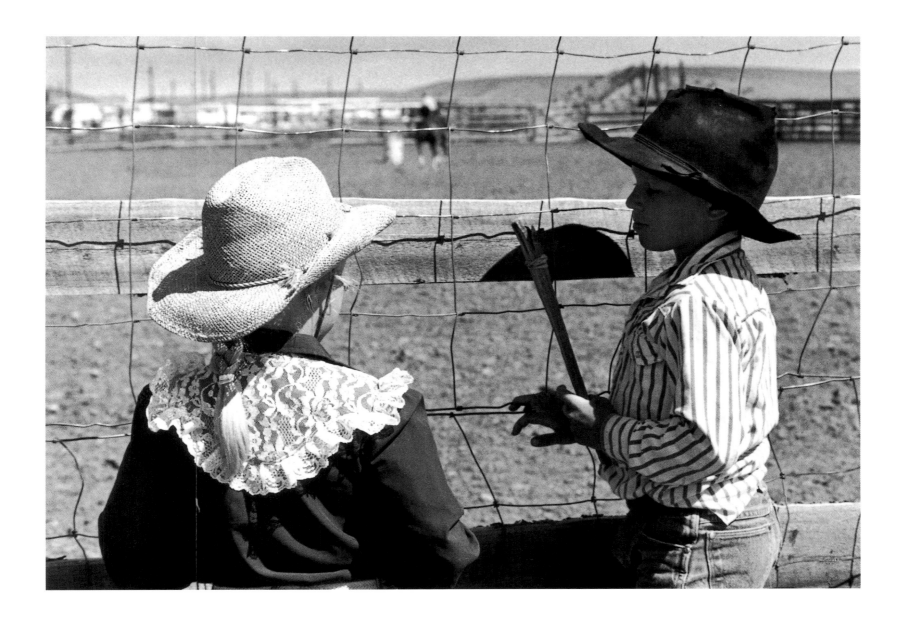

20. Lace Collar, Wilsall

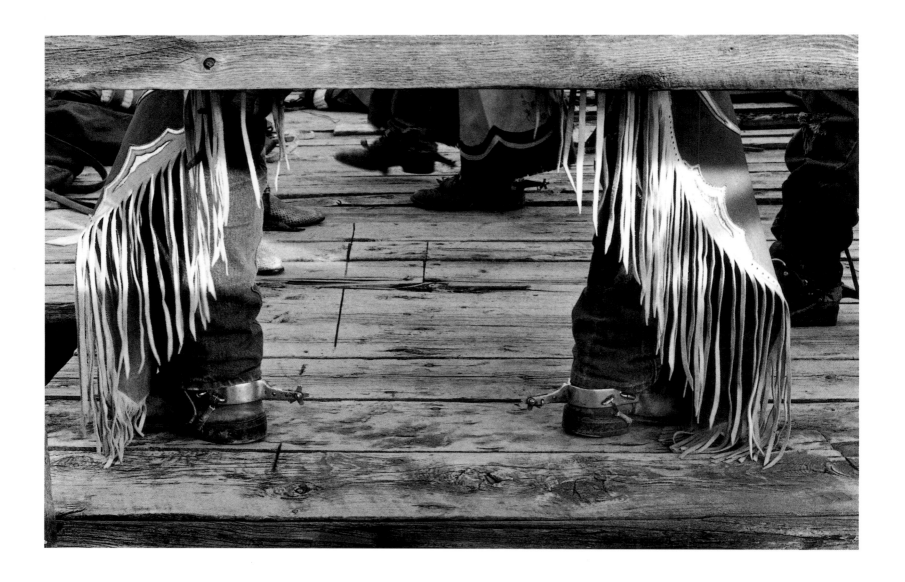

21. Rodeo Chaps, Three Forks

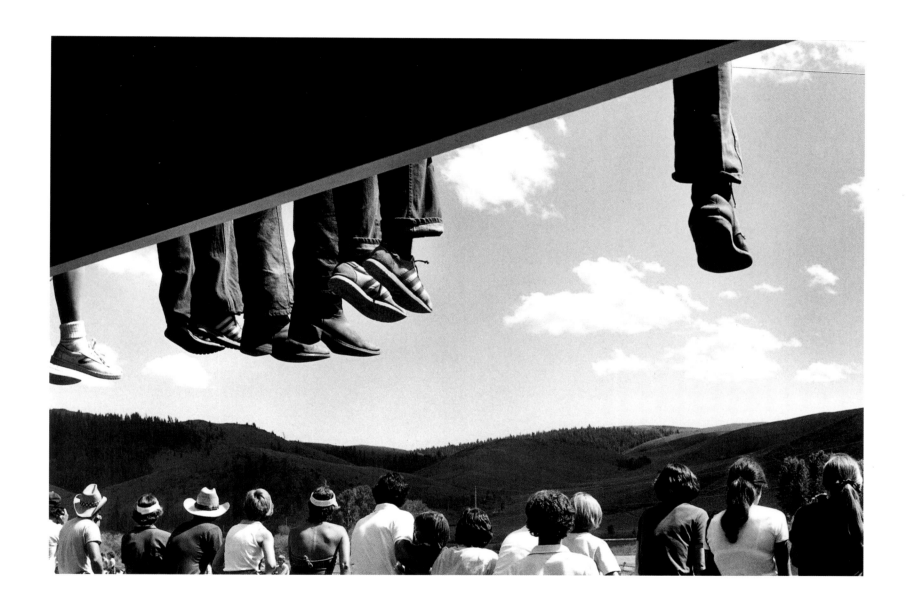

22. Encampment, Wyoming

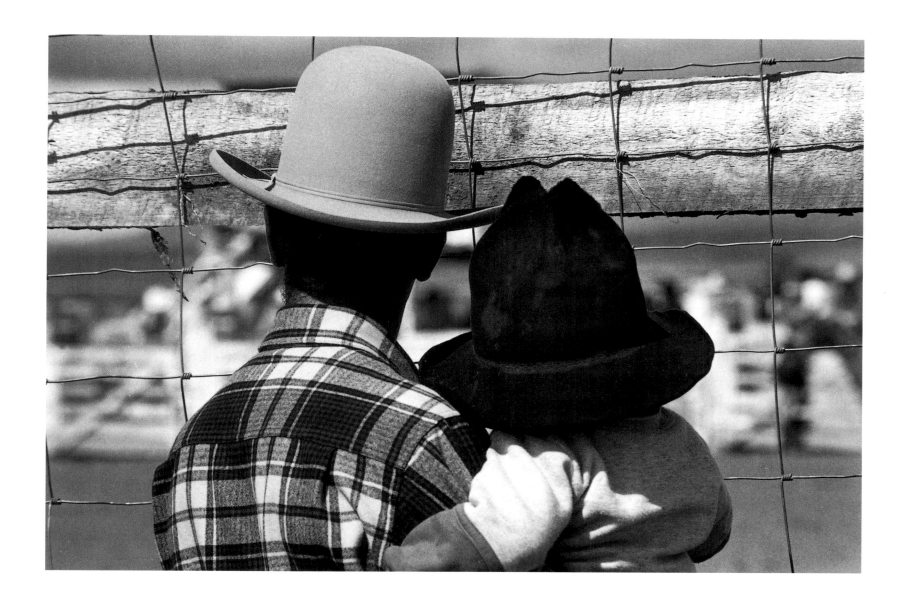

23. Two Hats, Wilsall

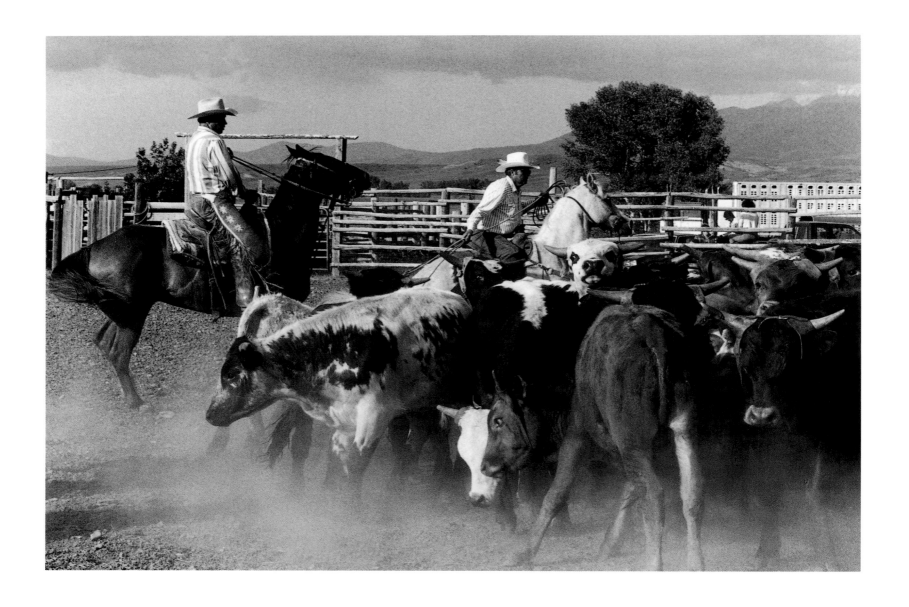

24. Bringing the Stock Back for Another Run, Wilsall

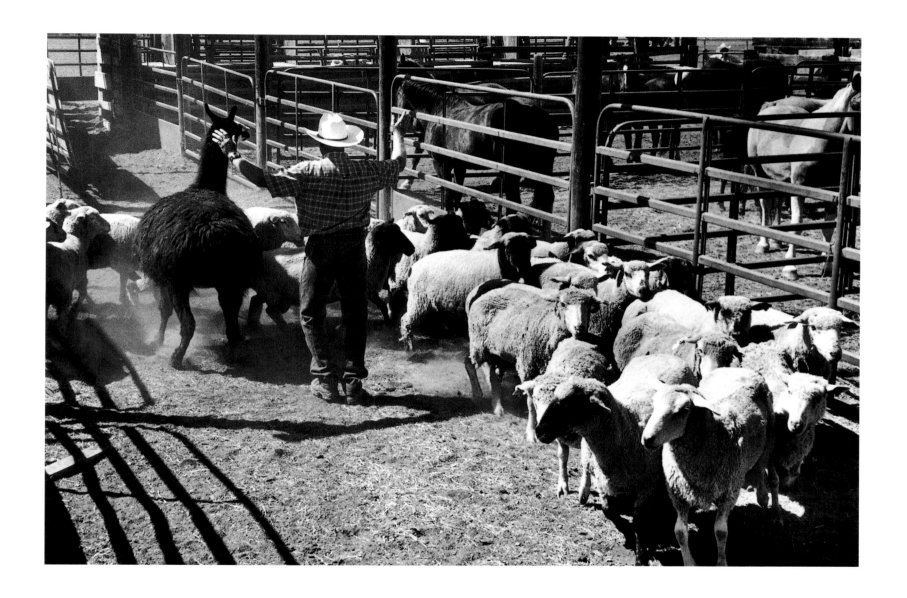

25. Moving the Sheep into the Holding Pen, Deer Lodge

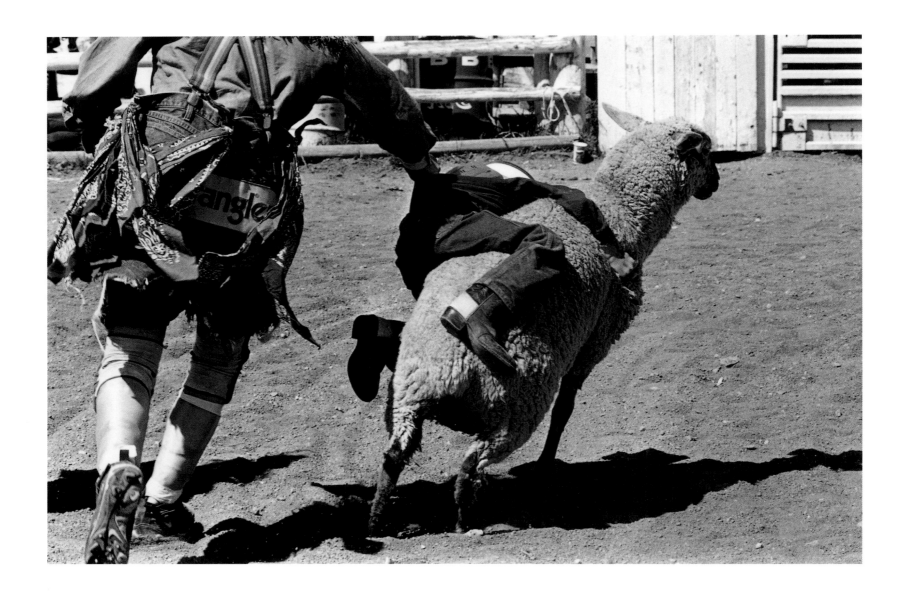

26. Bullfighter Helping a Young Sheep Rider, East Helena

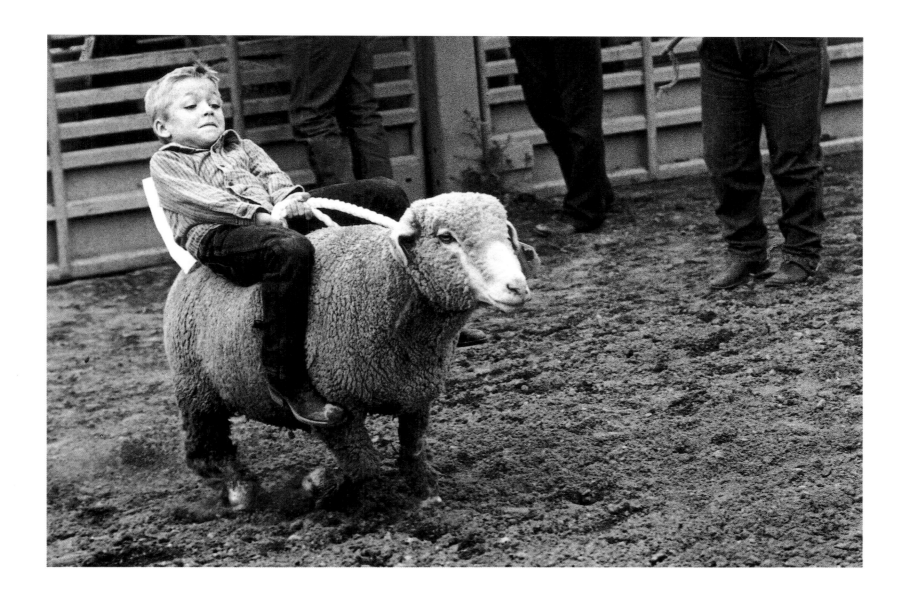

27. Sheep Riding (Mutton Bustin'), Bozeman

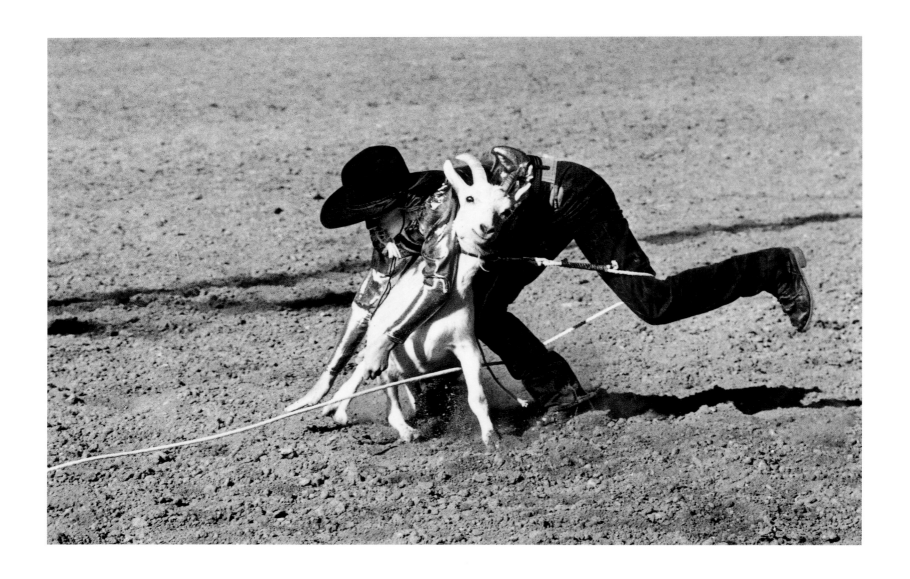

28. Goat Tying, Helena

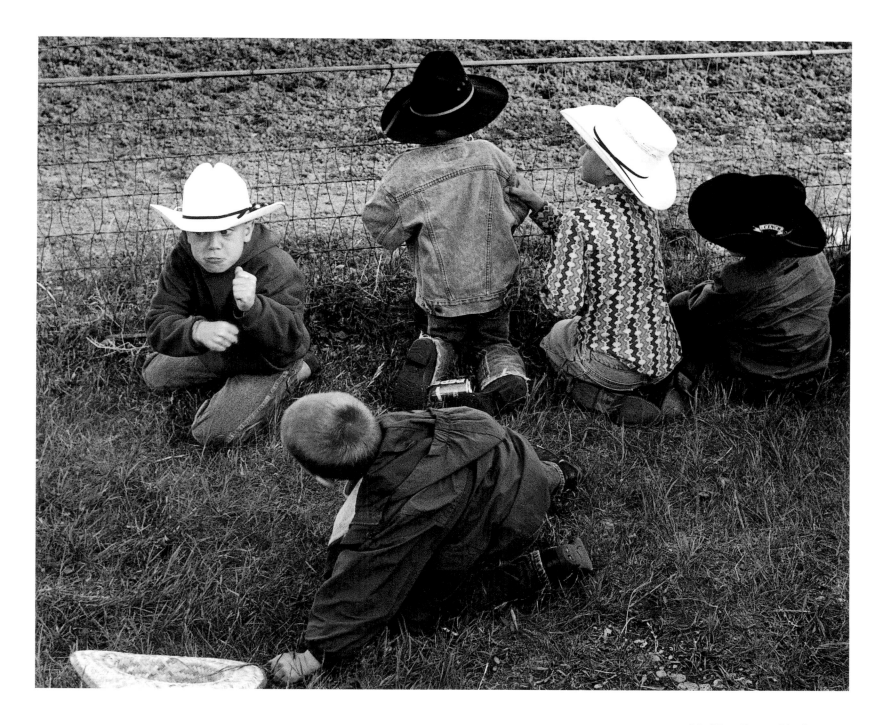

29. Five Boys, Harlowton

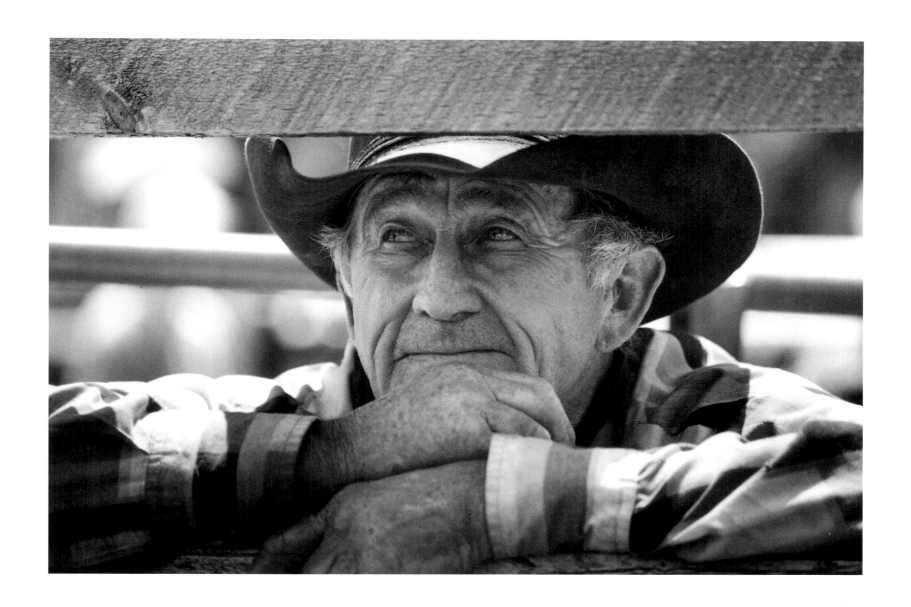

30. Cowboy, Augusta

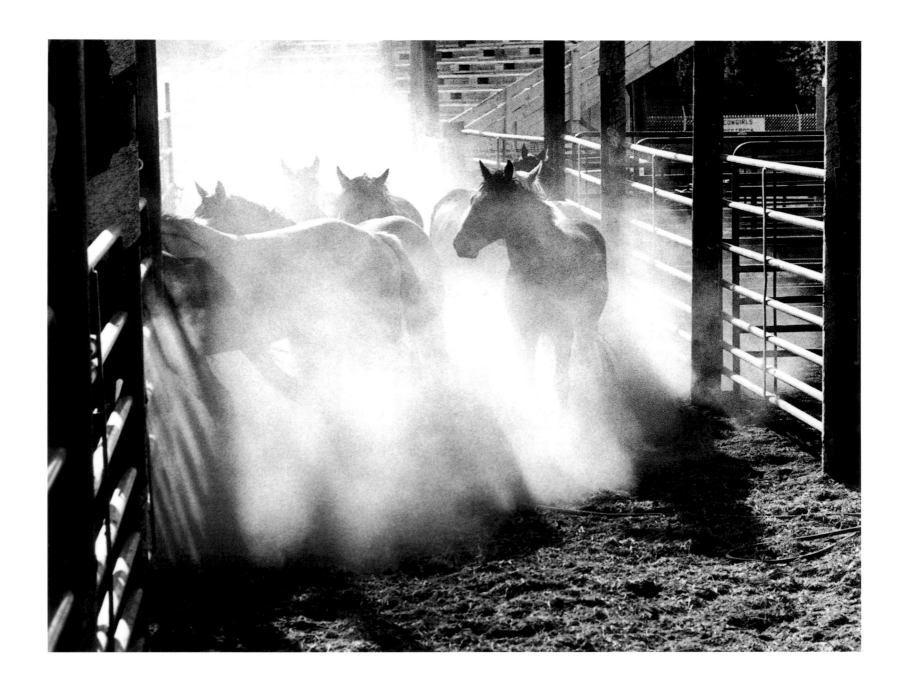

31. Horses Going into the Pen, Deer Lodge

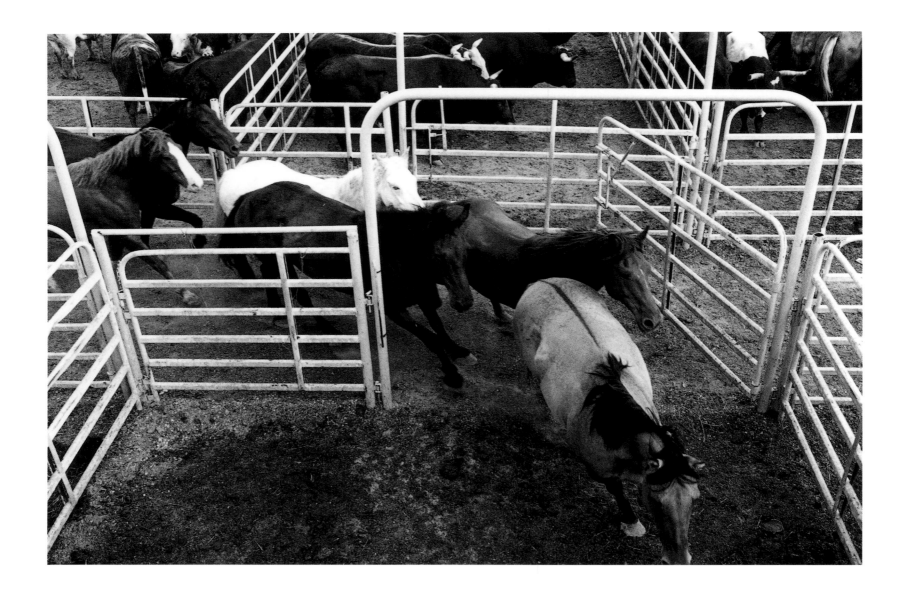

32. Bucking Horses Going into a Holding Pen, Lewistown

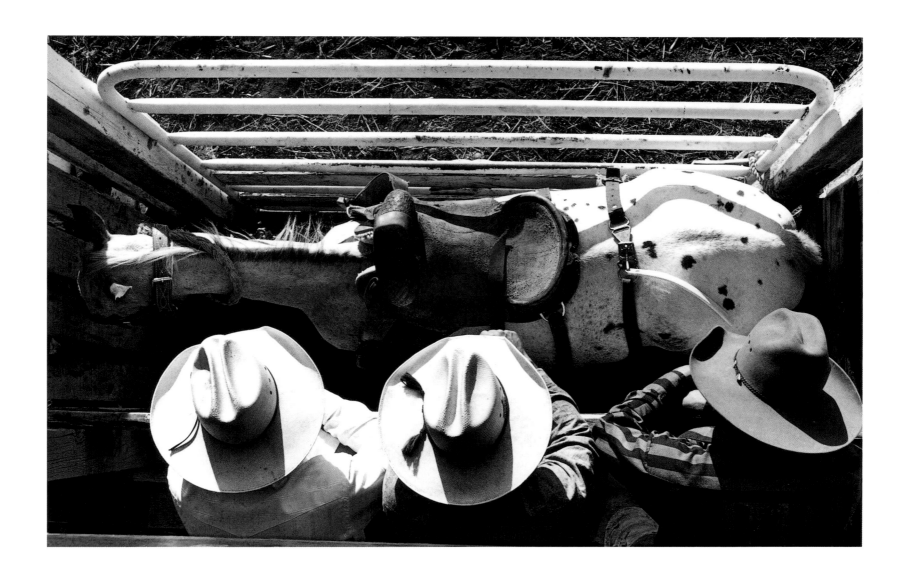

33. Three Hats, Three Forks

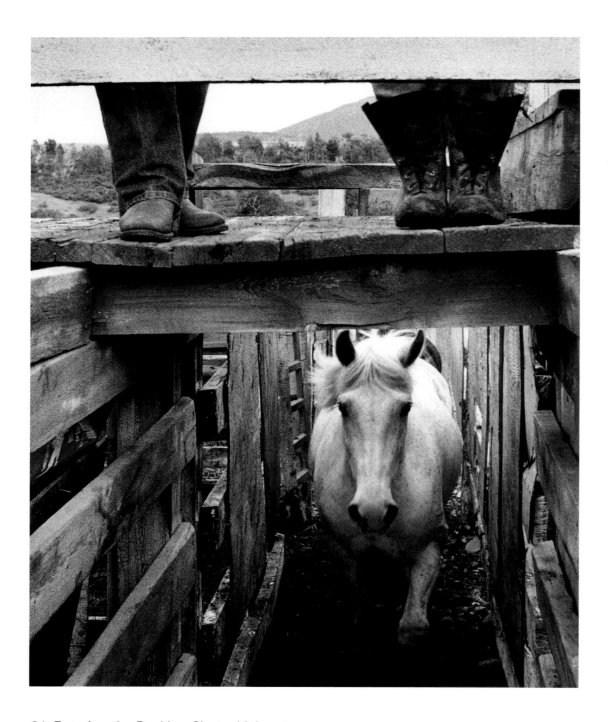

34. Entering the Bucking Chute, Livingston

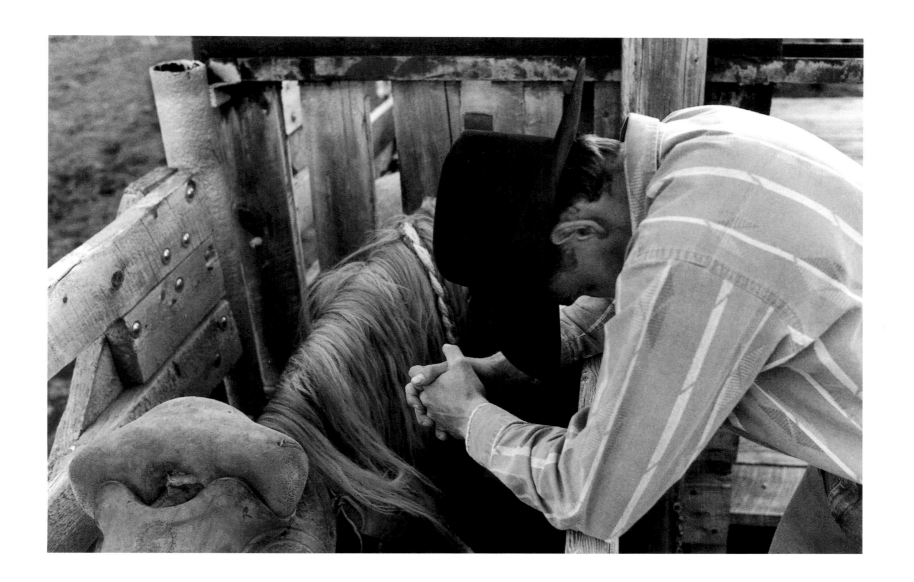

35. Prayer, Big Timber

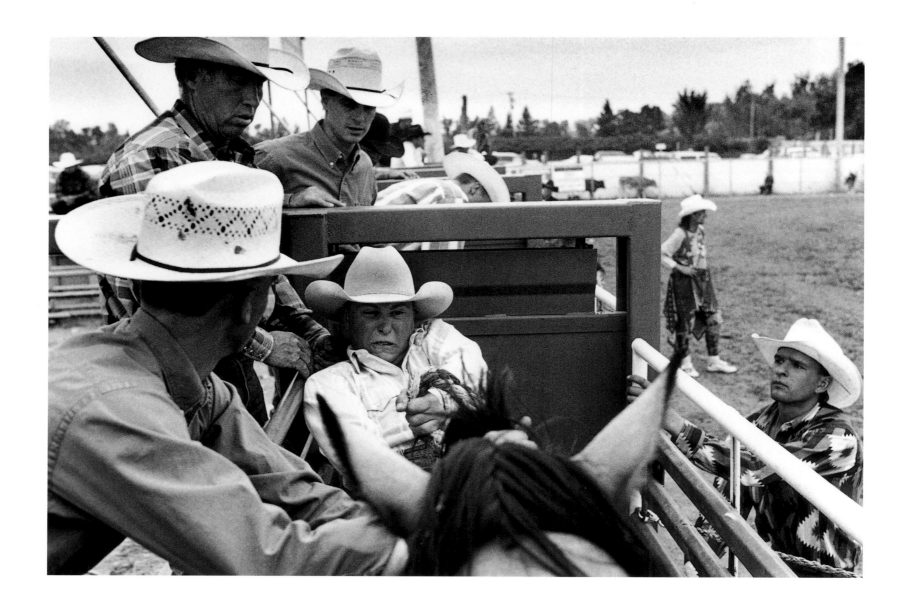

36. Saddle Bronc Rider Ready to Leave the Chute, Lewistown

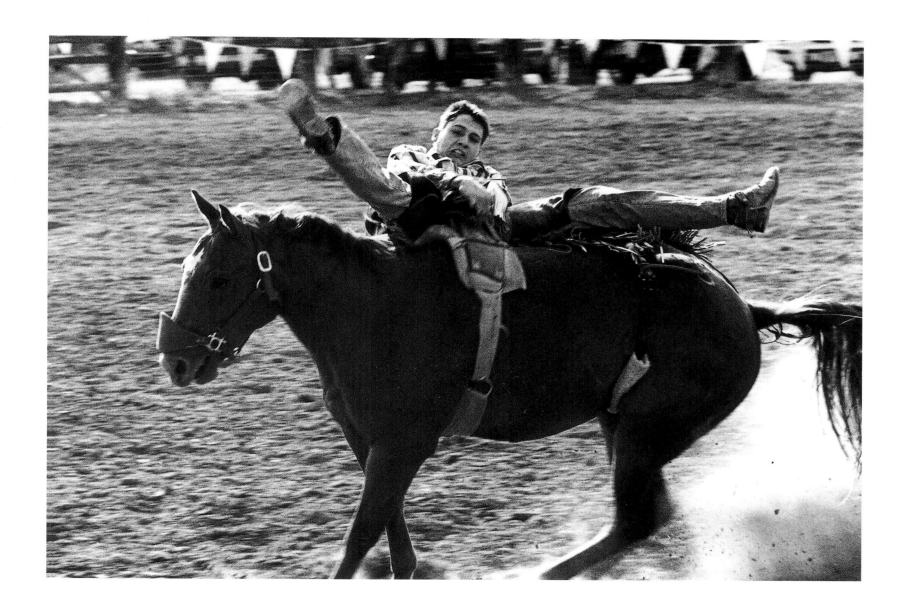

37. Bareback Rider, Whitehall

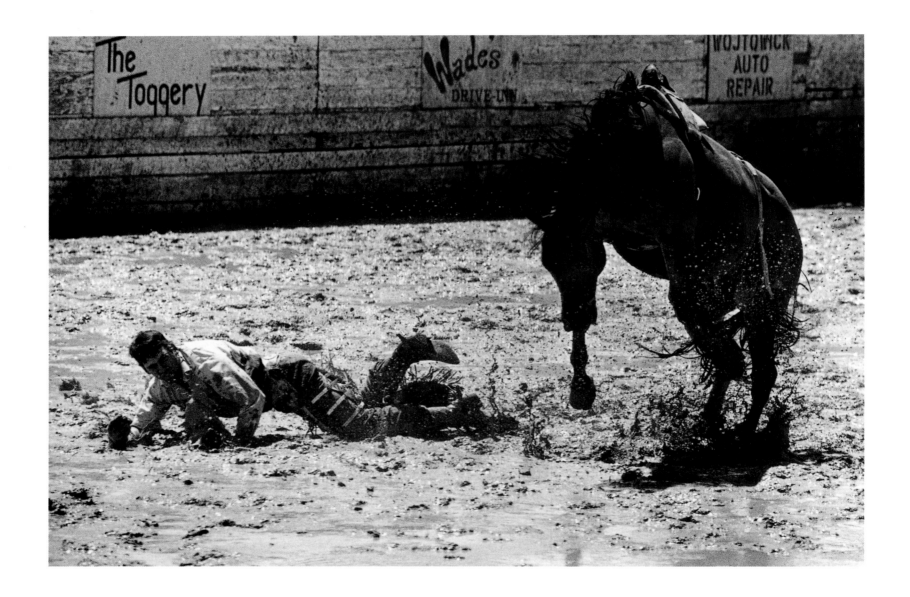

38. Bareback Rider, Harlowton

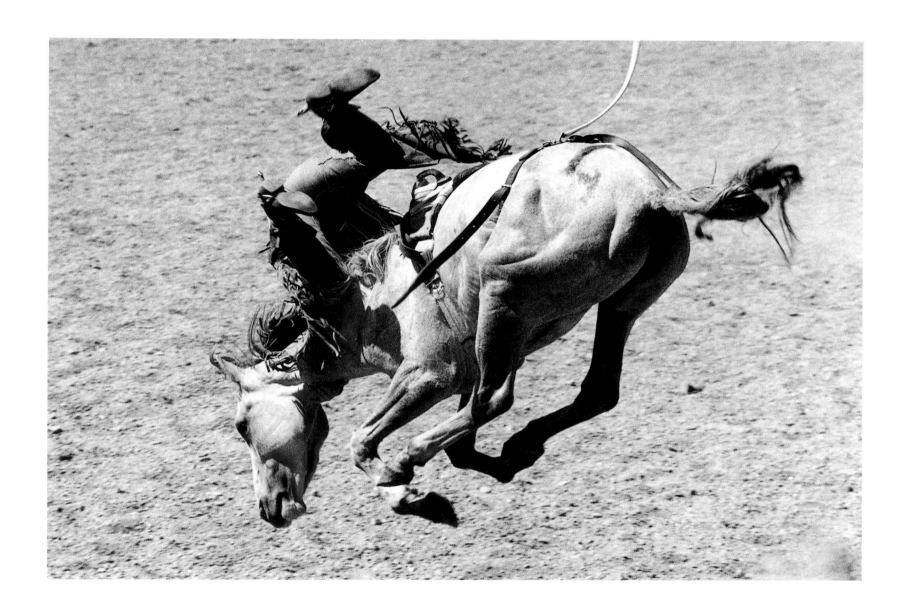

39. Bareback Rider, Lewistown

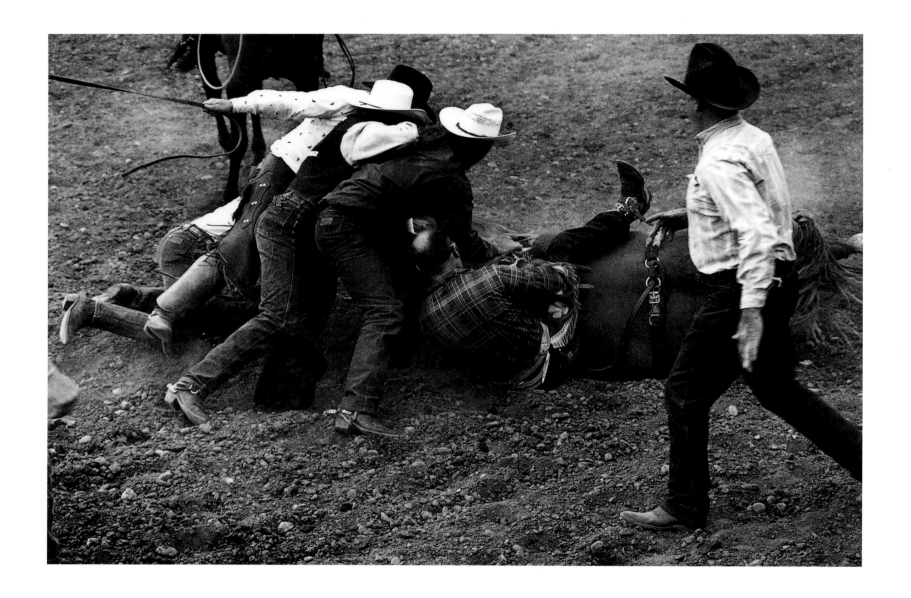

40. Bareback Rider Hung Up in Rigging, Big Timber

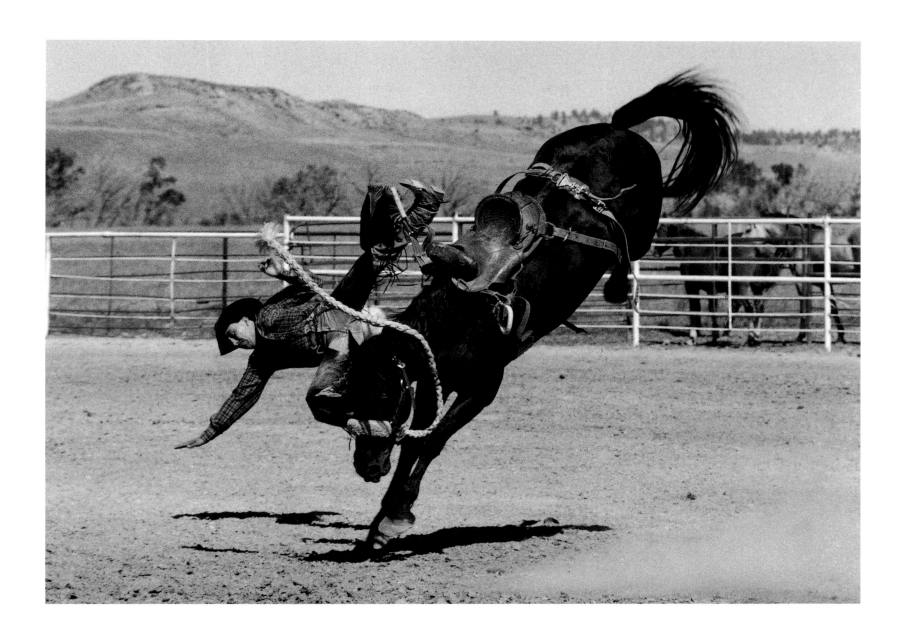

41. Saddle Bronc Rider, Crow Fair, Hardin

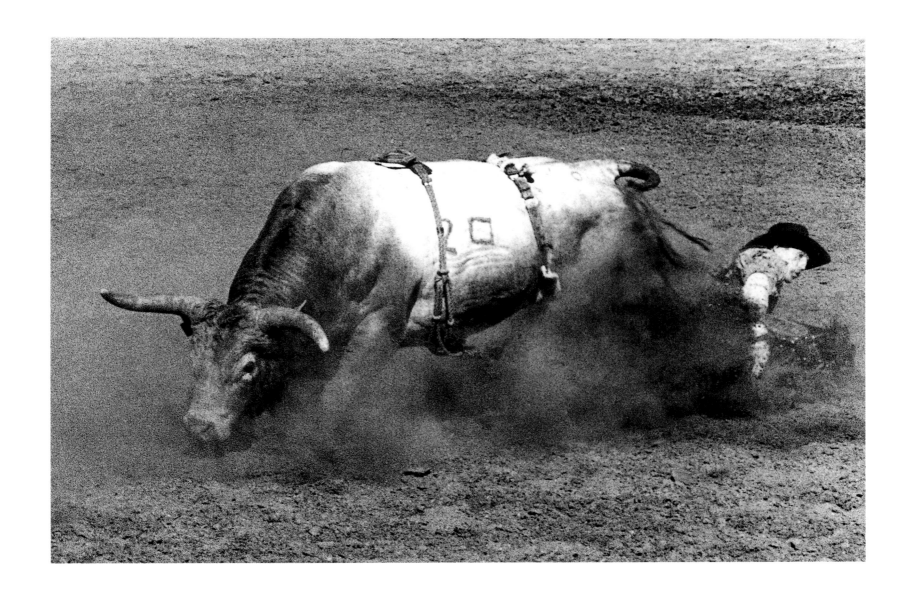

42. Bull Rider, Dillon

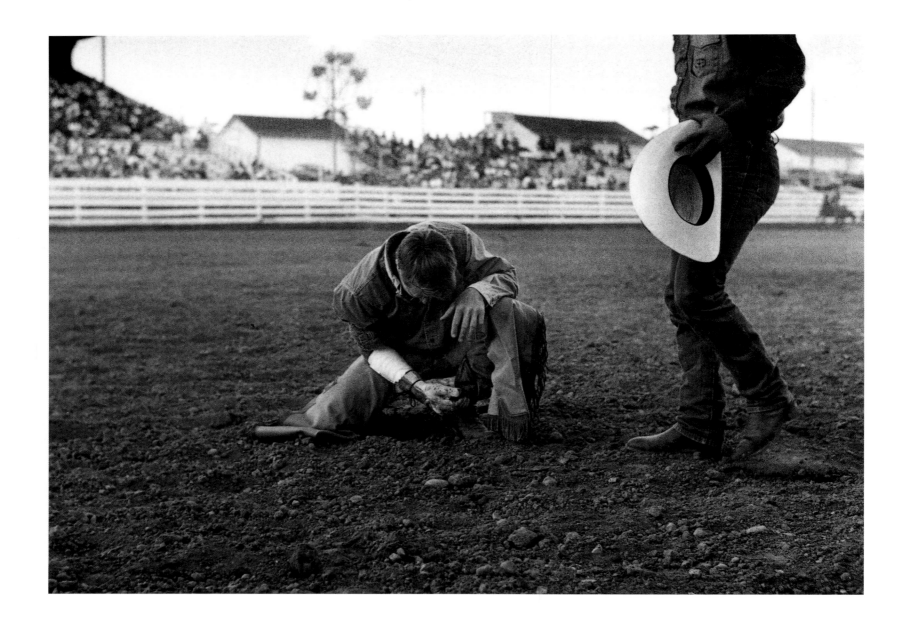

43. After, Havre

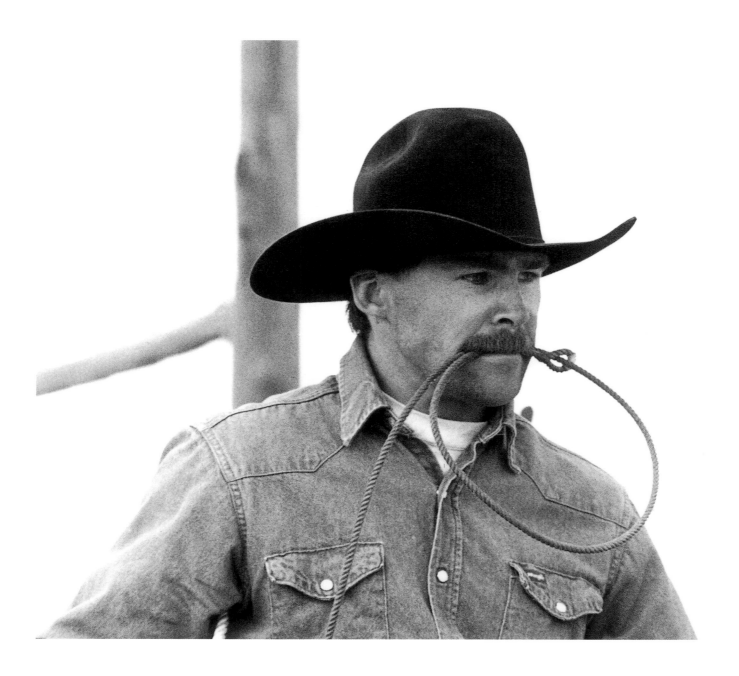

44. Cowboy with "Piggin" String for Tie-down Roping, Ingomar

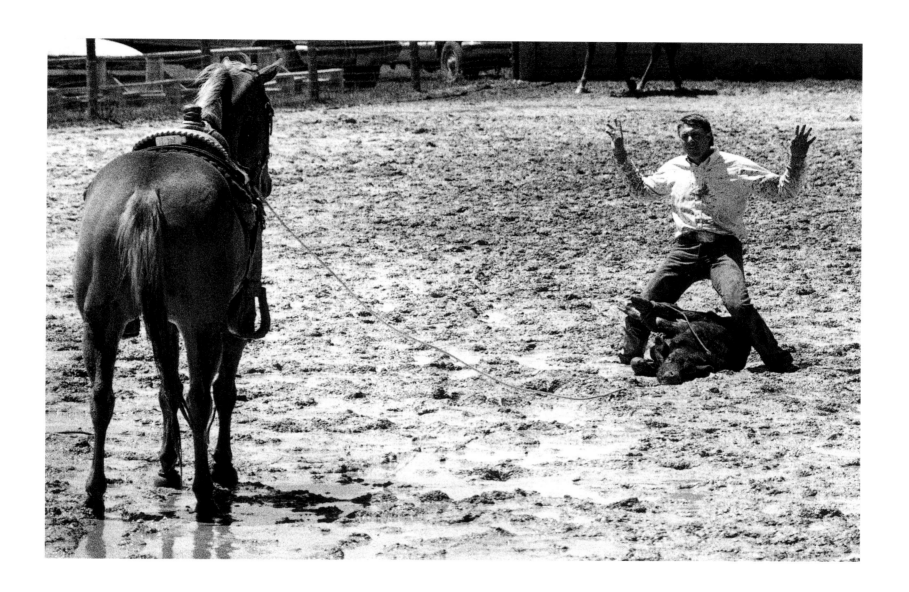

45. Tie-down Roping, Harlowton

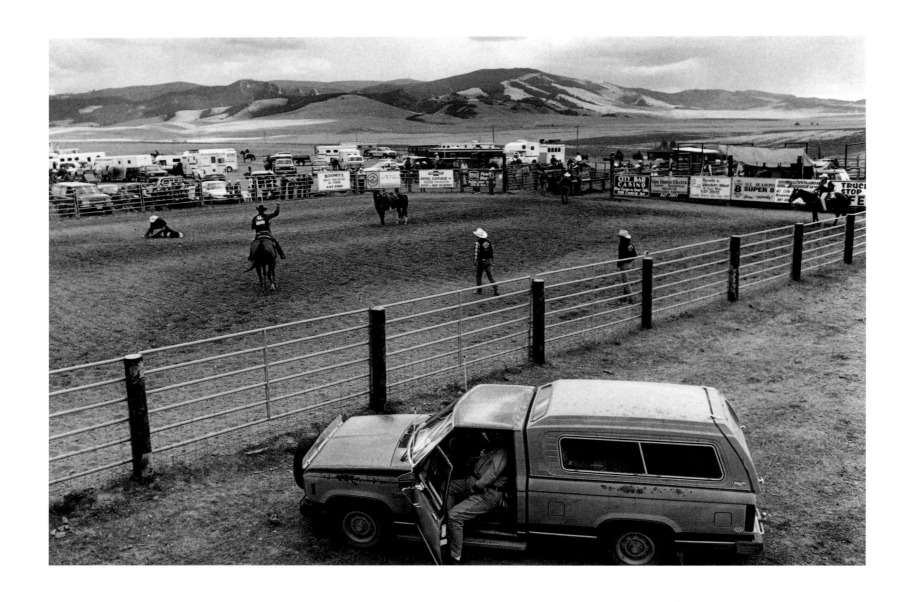

46. Tie-down Roping, White Sulphur Springs

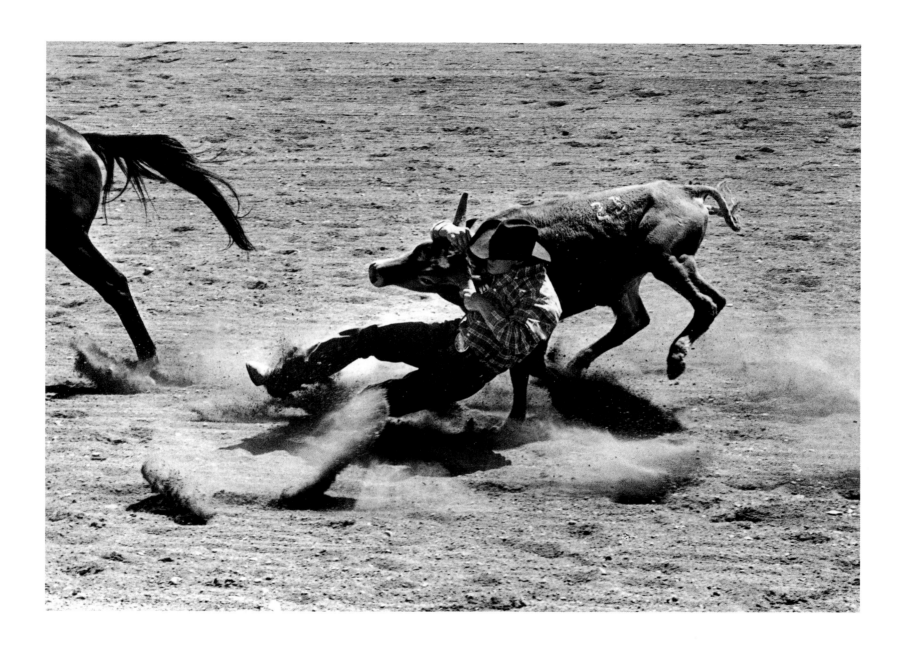

47. Steer Wrestling, Deer Lodge

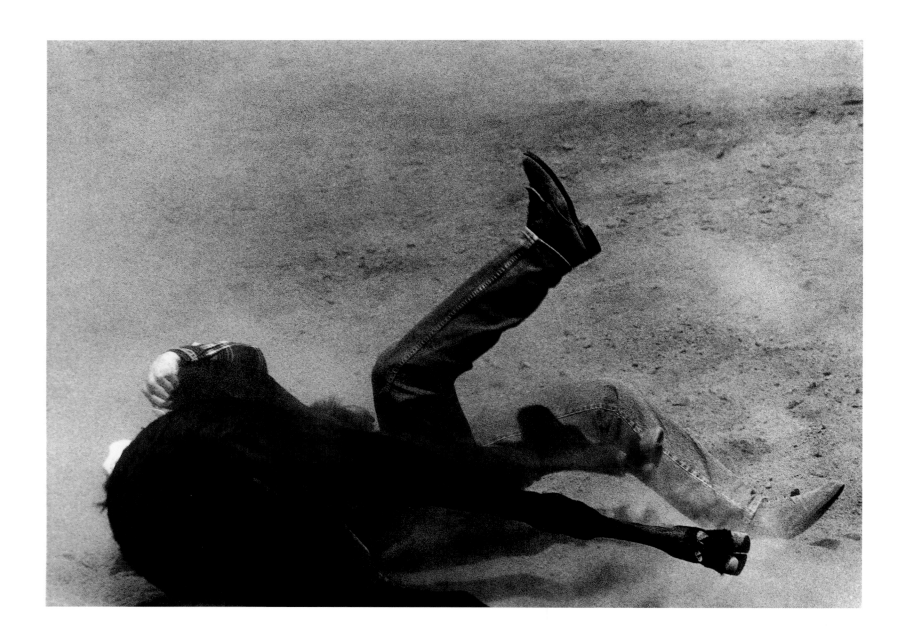

48. Steer Wrestling, Boulder

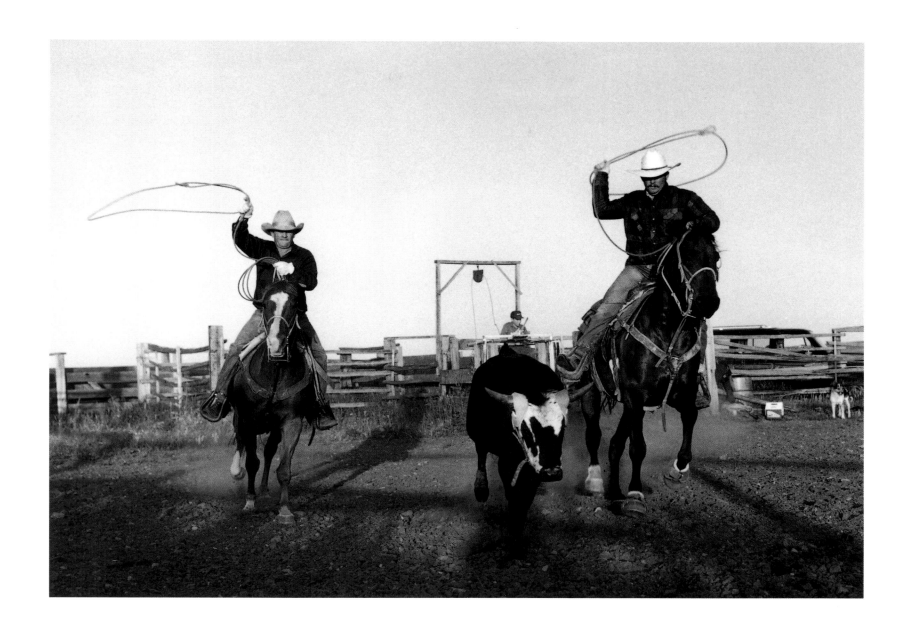

49. Team Roping, Logan's Ranch, Clyde Park

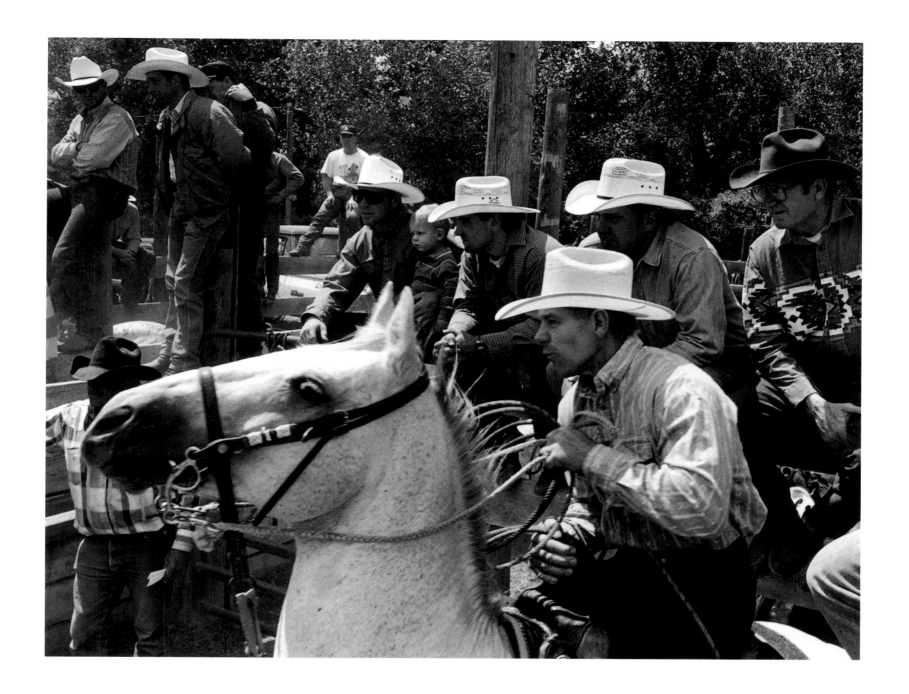

50. Team Roper Leaving the Box, Augusta

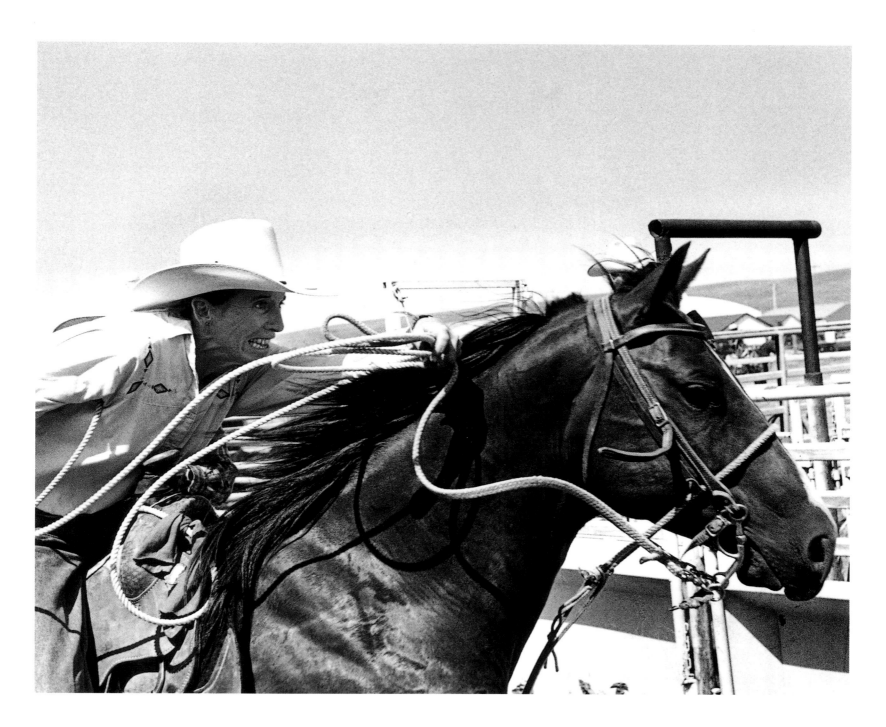

51. Breakaway Roper, Lewistown

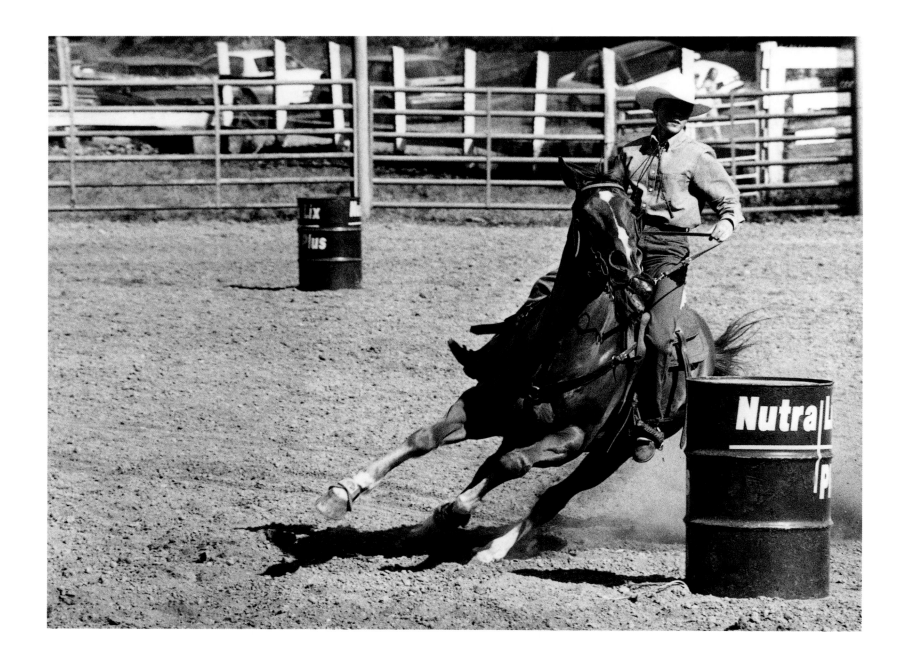

52. Barrel Racer, Roundup

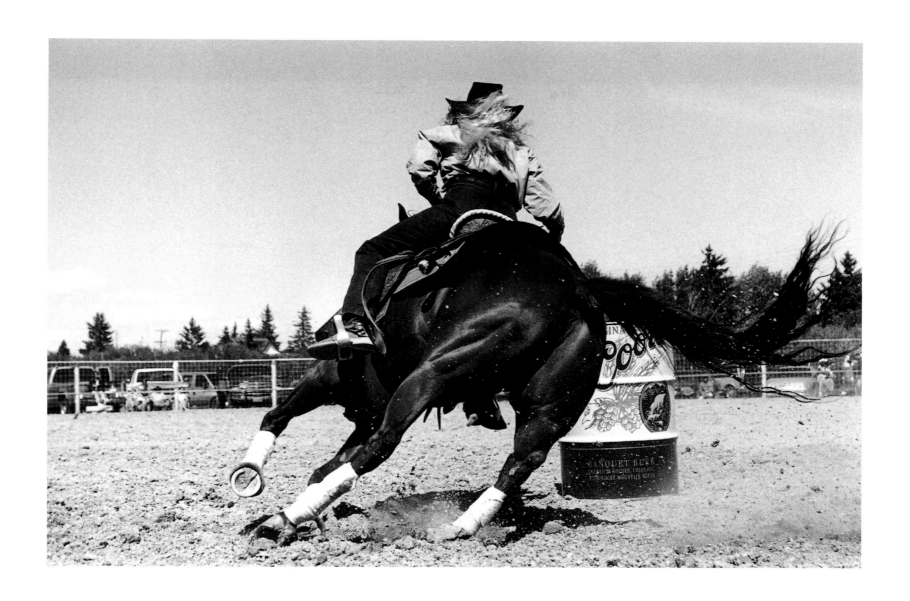

53. Barrel Racer, Stanford

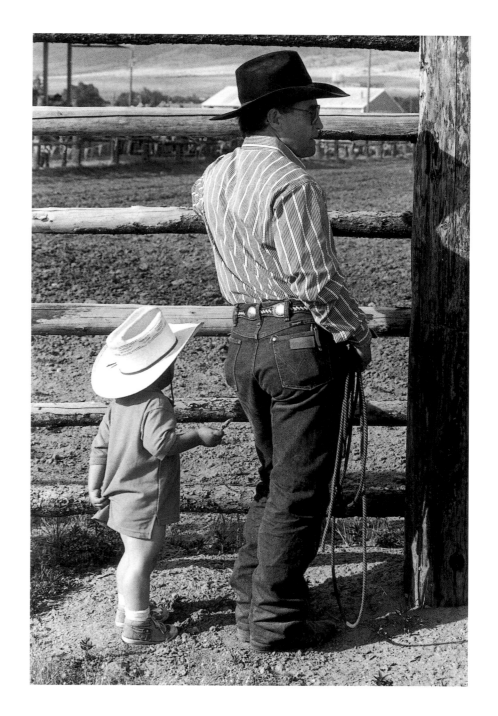

54. Father and Son, Whitehall

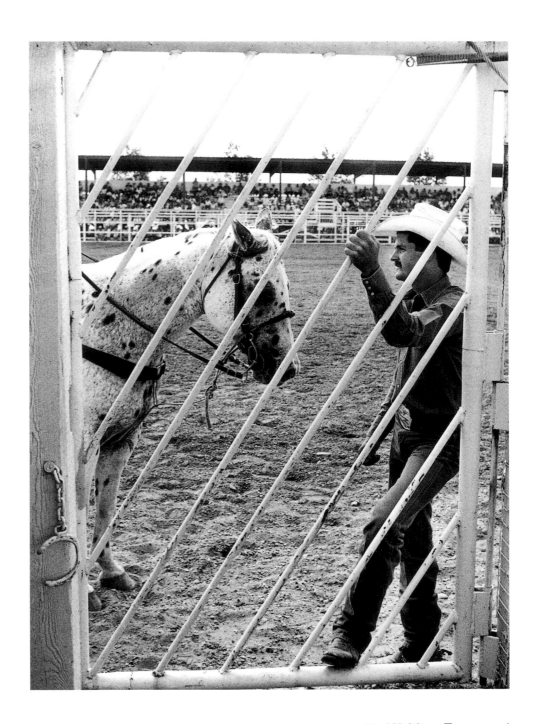

55. Waiting, Townsend

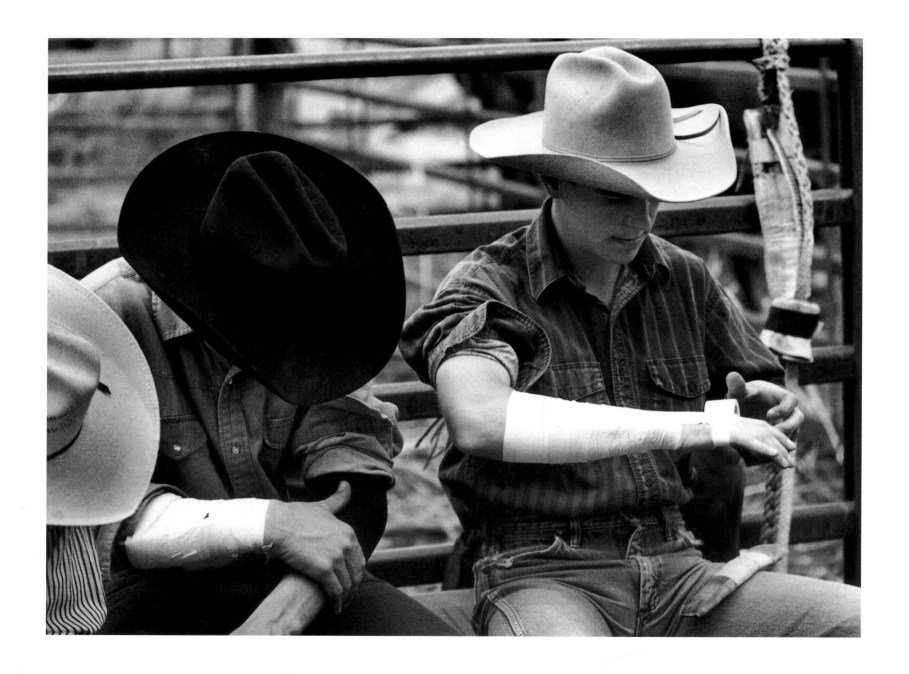

56. Bareback Riders, Three Forks

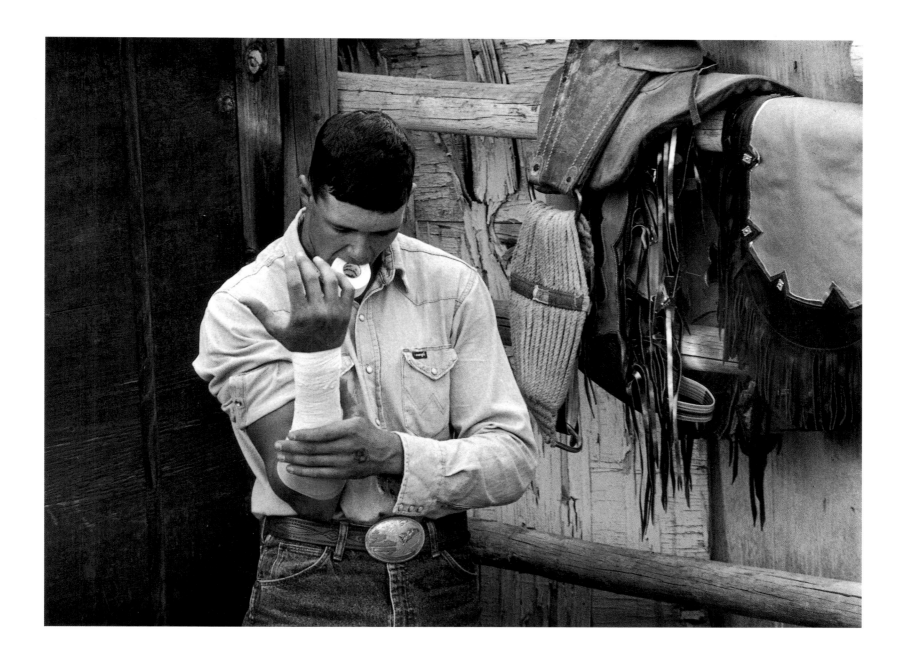

57. Bareback Rider Wrapping, East Helena

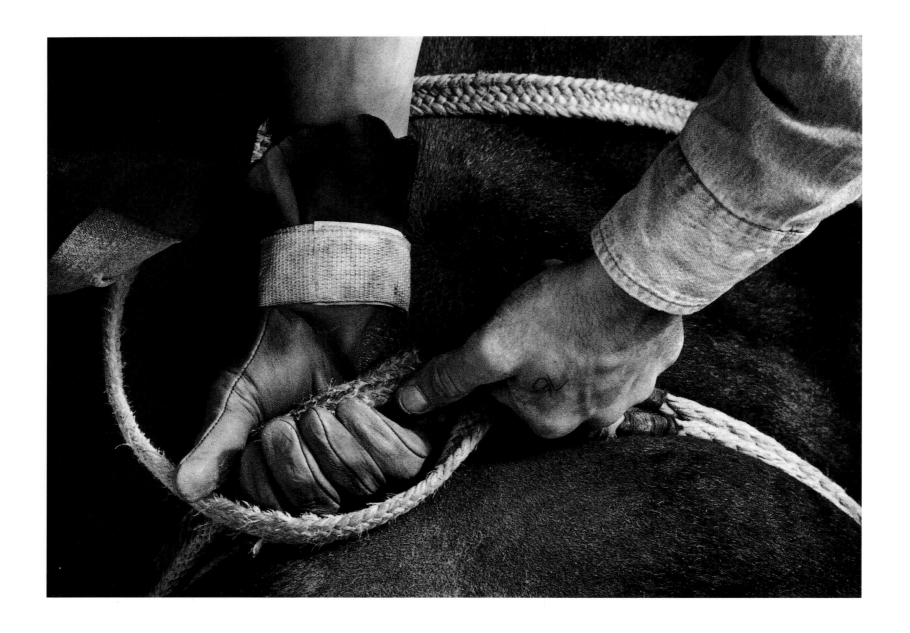

58. Bull Rider's "76" Hands, Big Timber

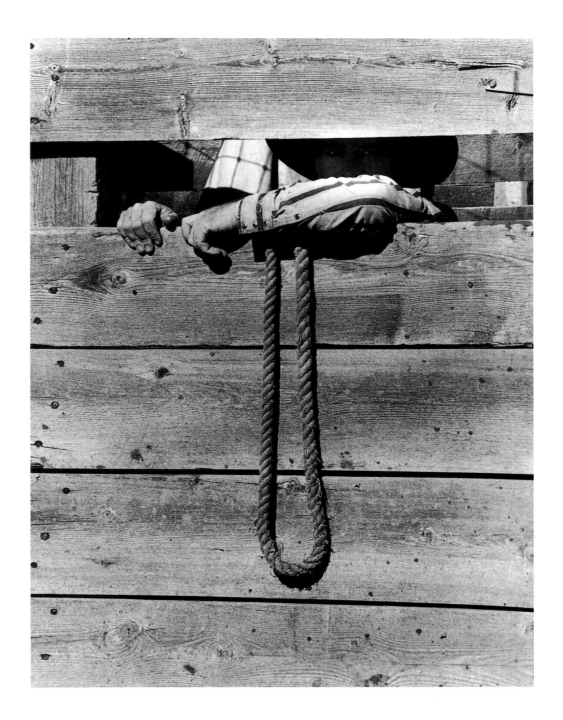

59. Watching, Harlowton

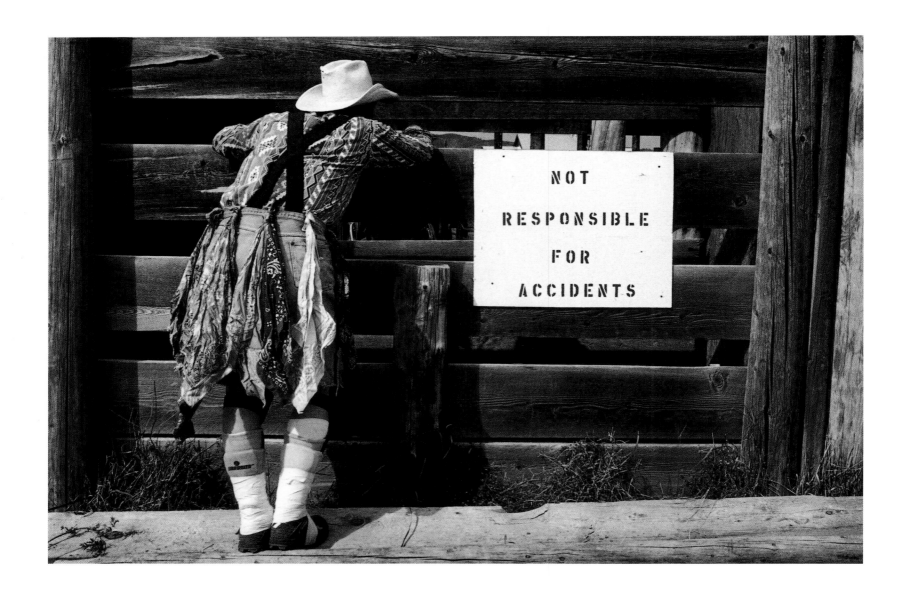

60. Bullfighter, White Sulphur Springs

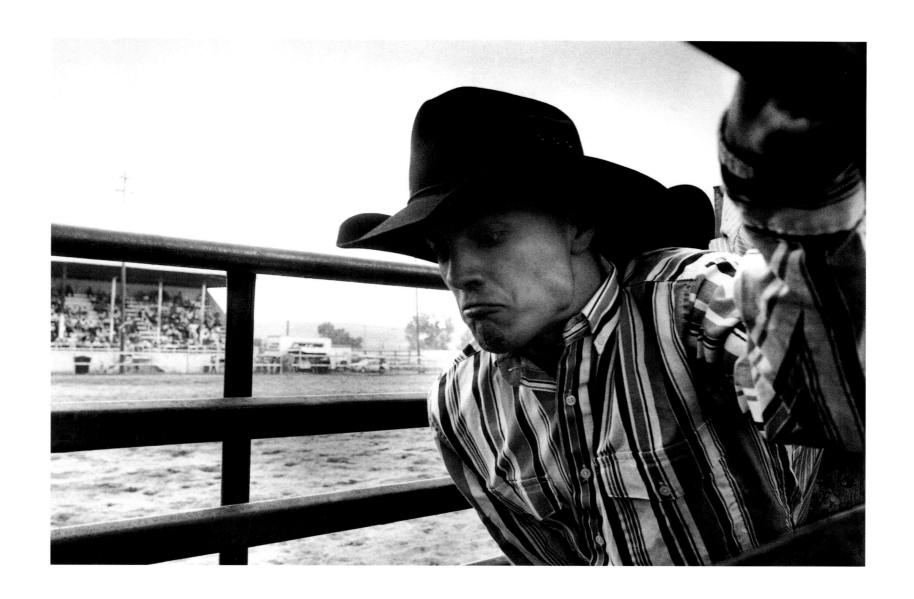

61. Bull Rider, Deer Lodge

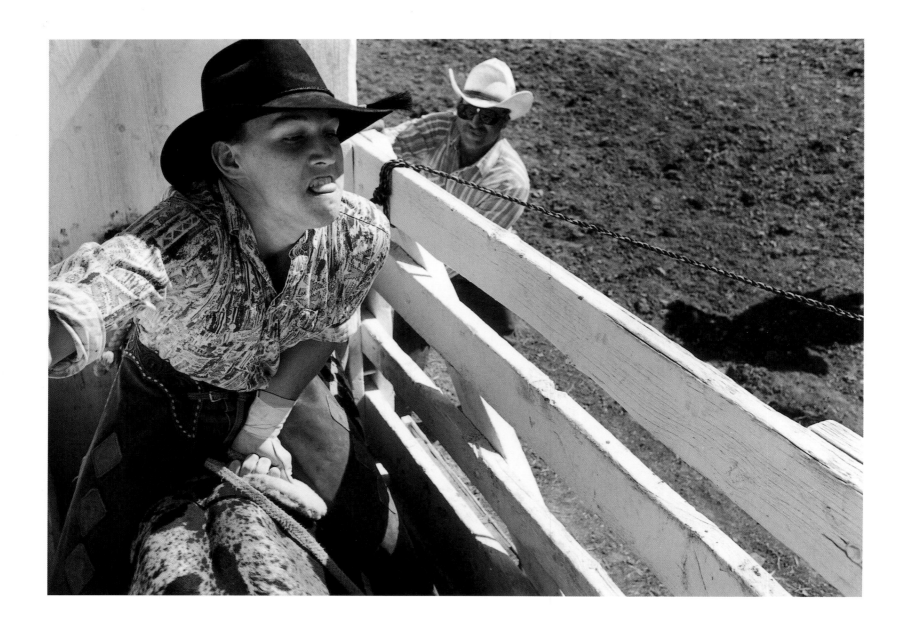

62. Bull Rider, Wilsall

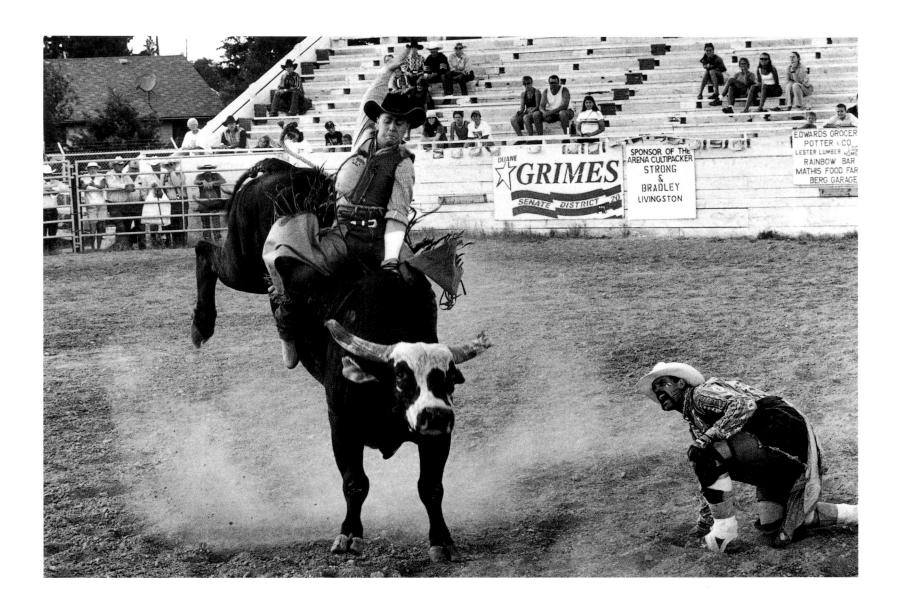

63. Bull Rider and Bullfighter, White Sulphur Springs

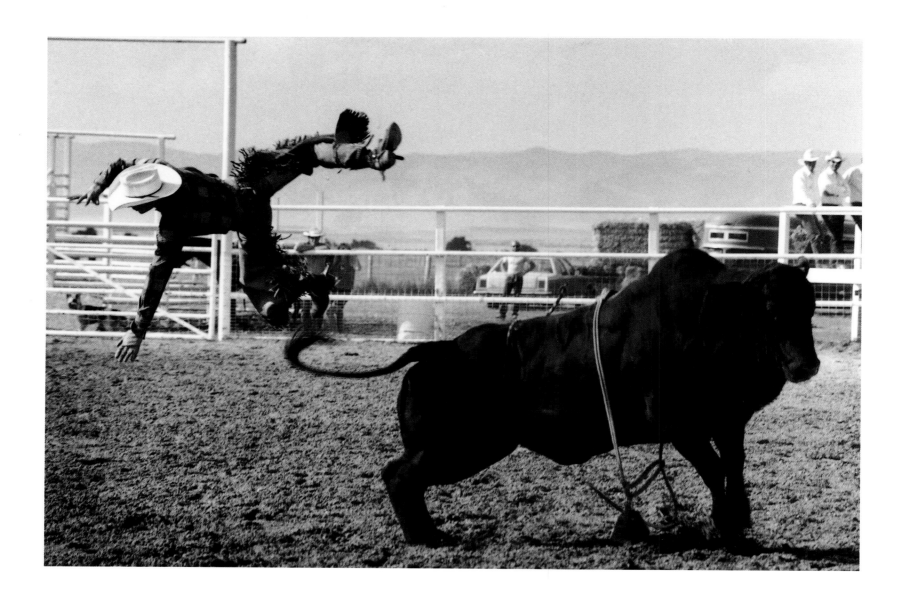

64. Bull Rider, Townsend

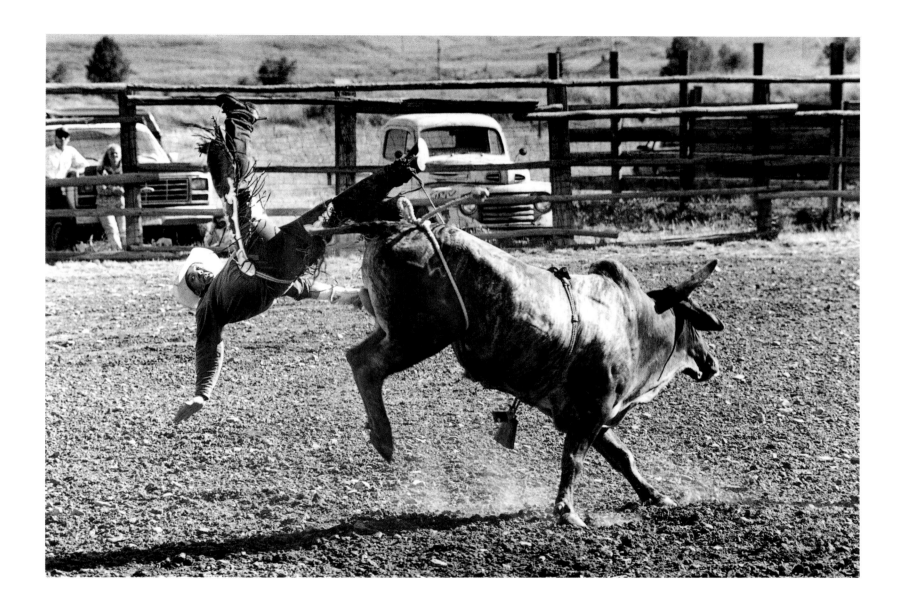

65. Bull Rider, Wilsall

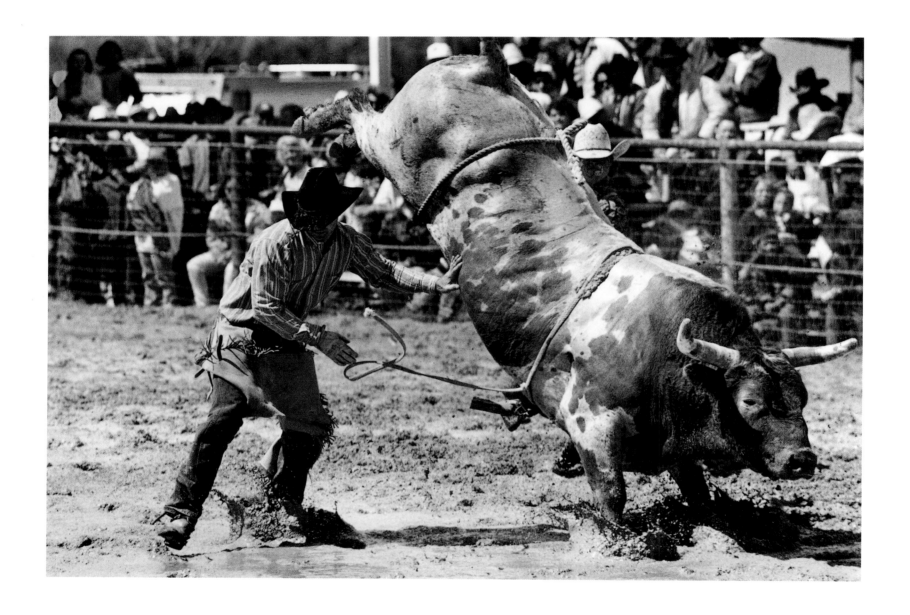

66. Bull "Ballet," Harlowton

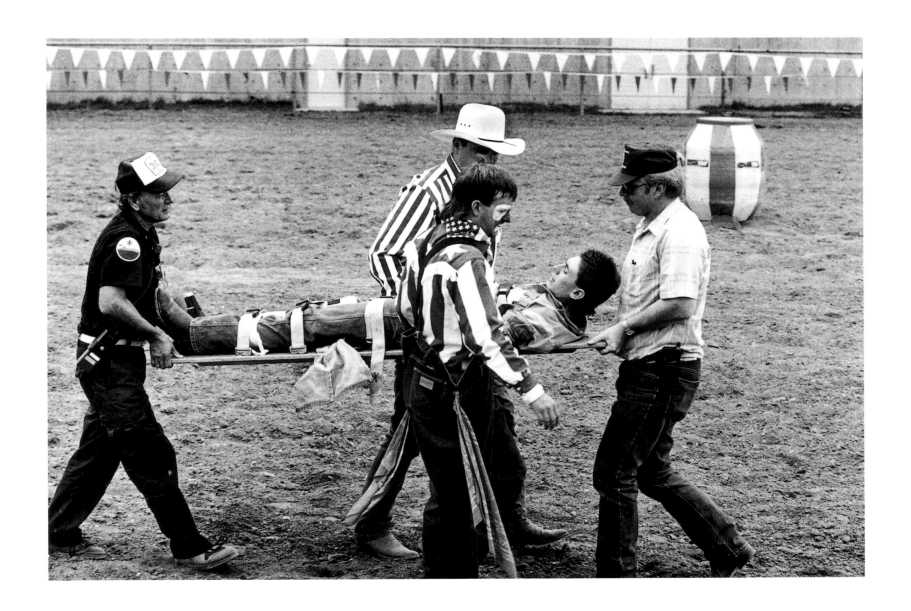

67. Rodeo Clown Assisting Medics, Big Timber

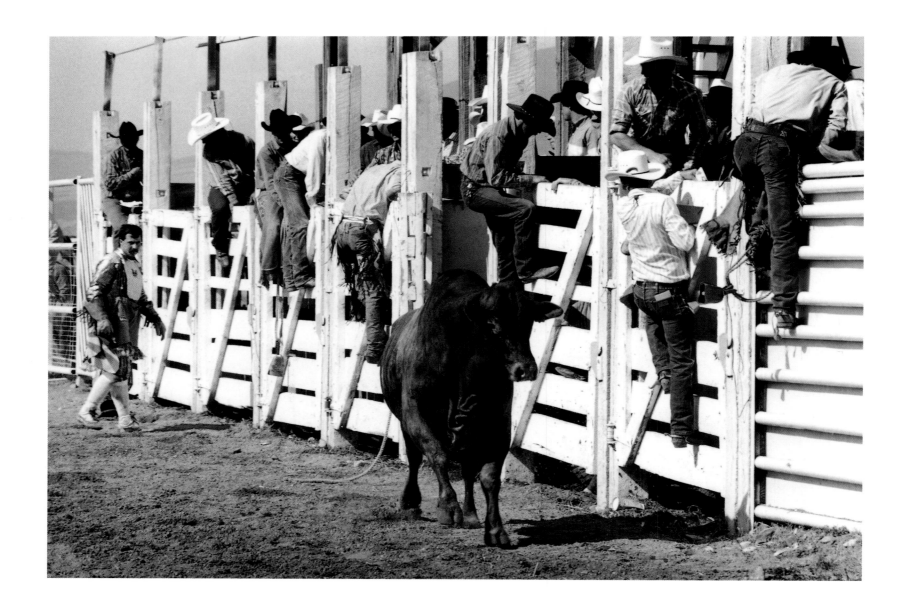

68. Loose Bull, Townsend

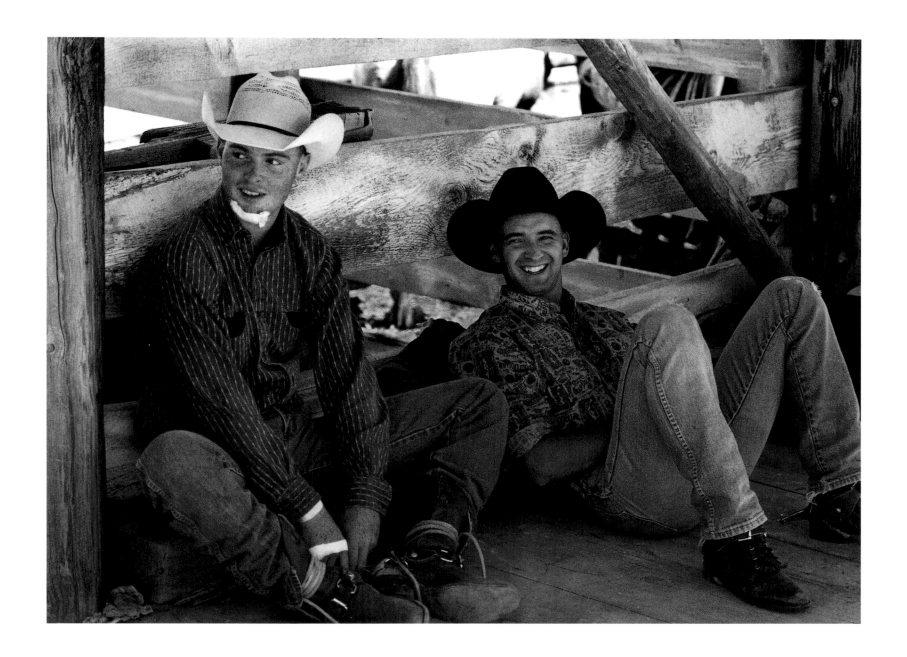

69. Waiting, Wilsall

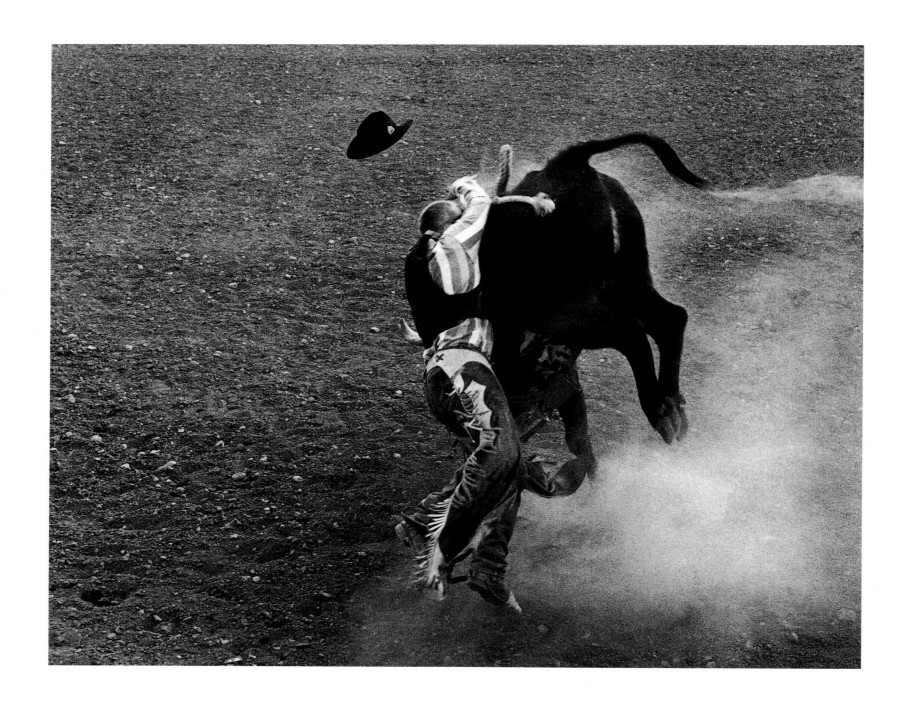

70. Bull Rider, Big Timber

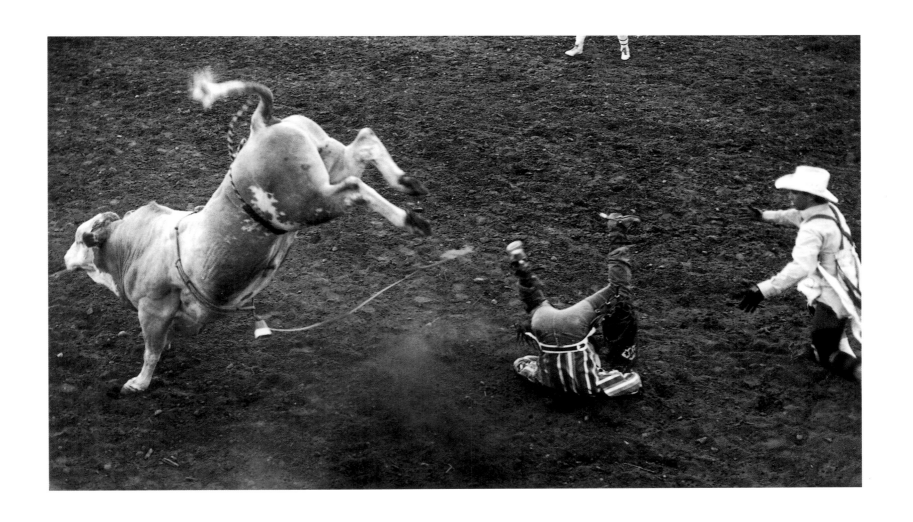

71. Bull Rider and Bullfighter, Three Forks

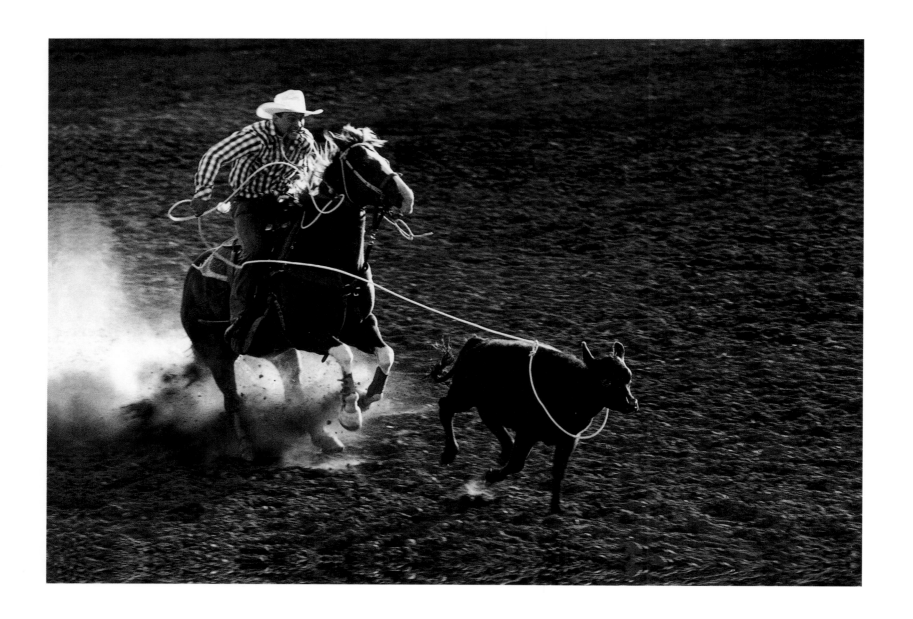

72. Calf Roper, Three Forks

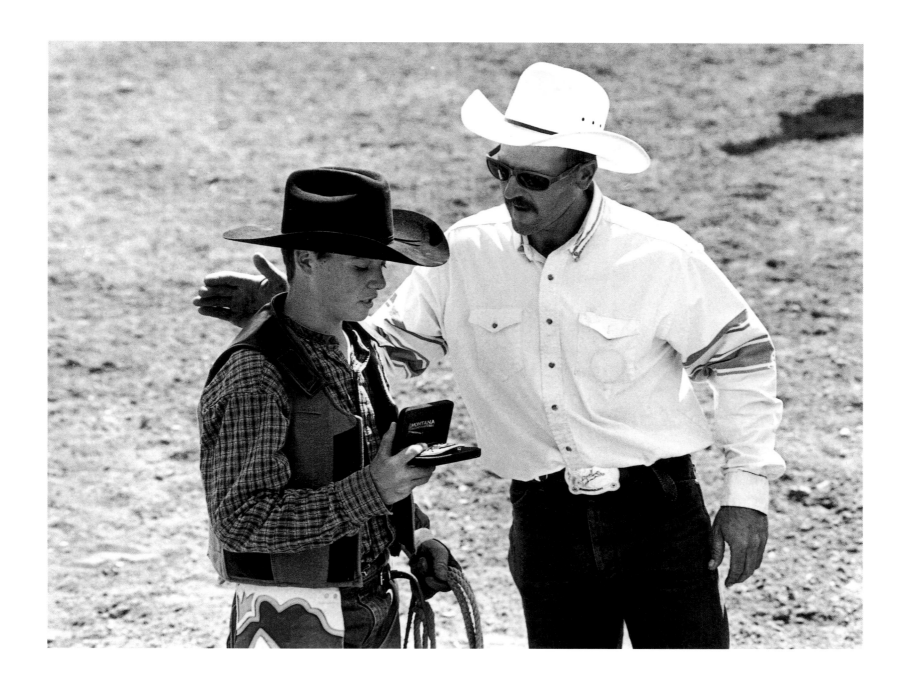

73. Young Cowboy Receiving Belt Buckle Award, Lewistown

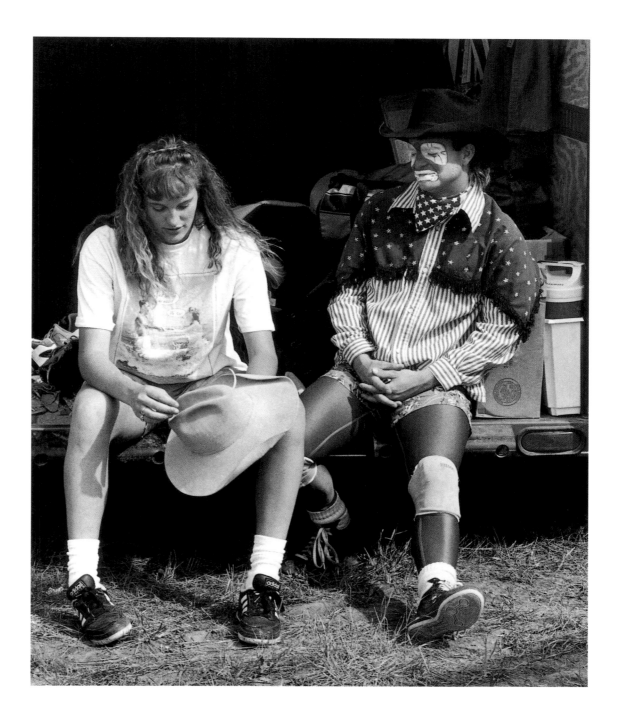

74. Rodeo Clown and Friend, Wilsall

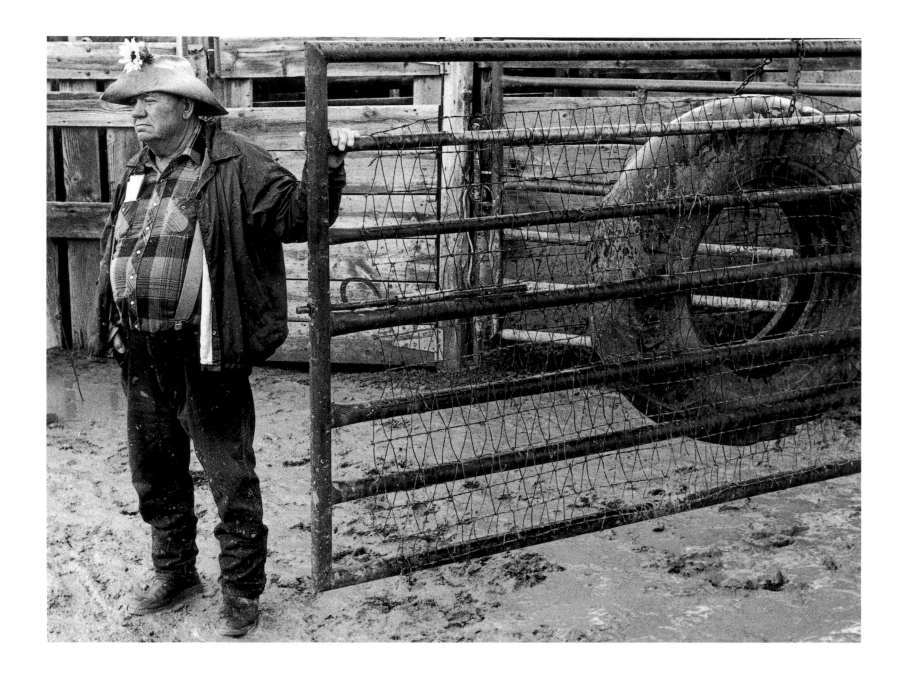

75. Gate Man, Harlowton

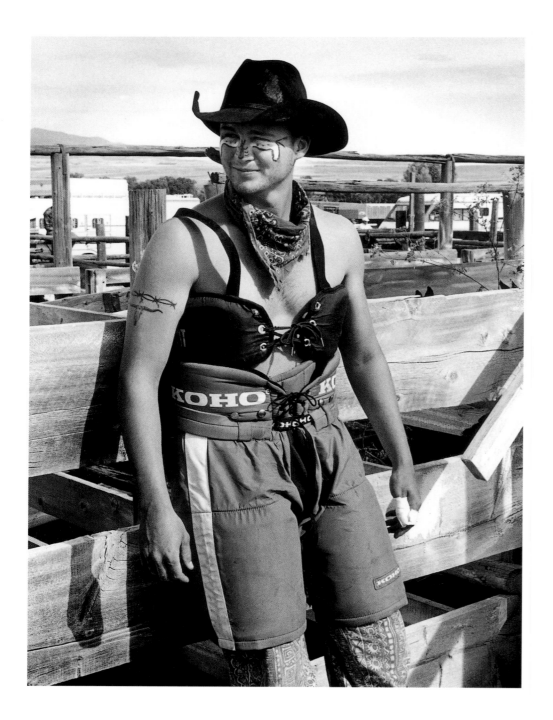

76. Bullfighter, Wilsall

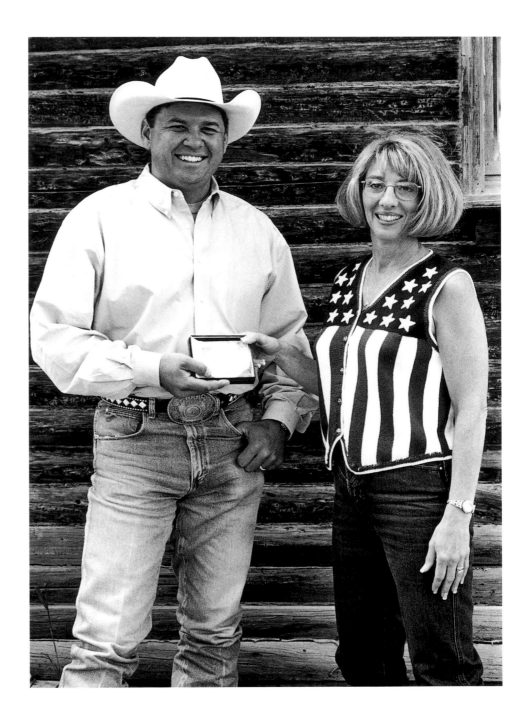

77. Cowboy Being Awarded Buckle for Calf Roping, Ennis

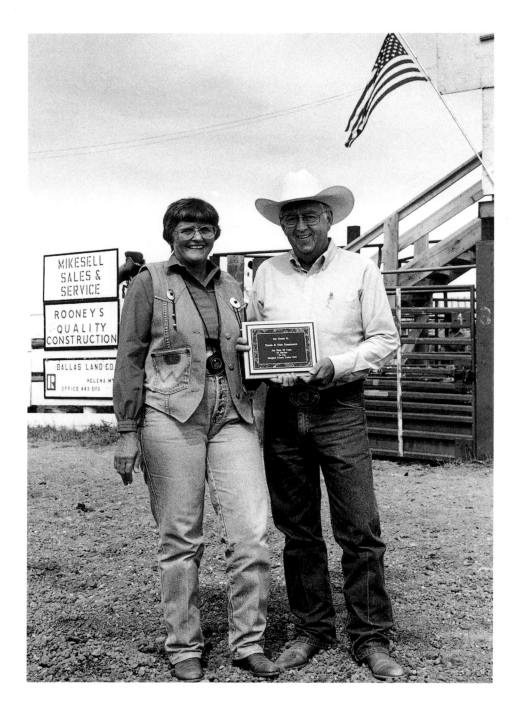

78. Award for Thirty-Five Consecutive Years of Timing and Announcing at White Sulphur Springs Rodeo

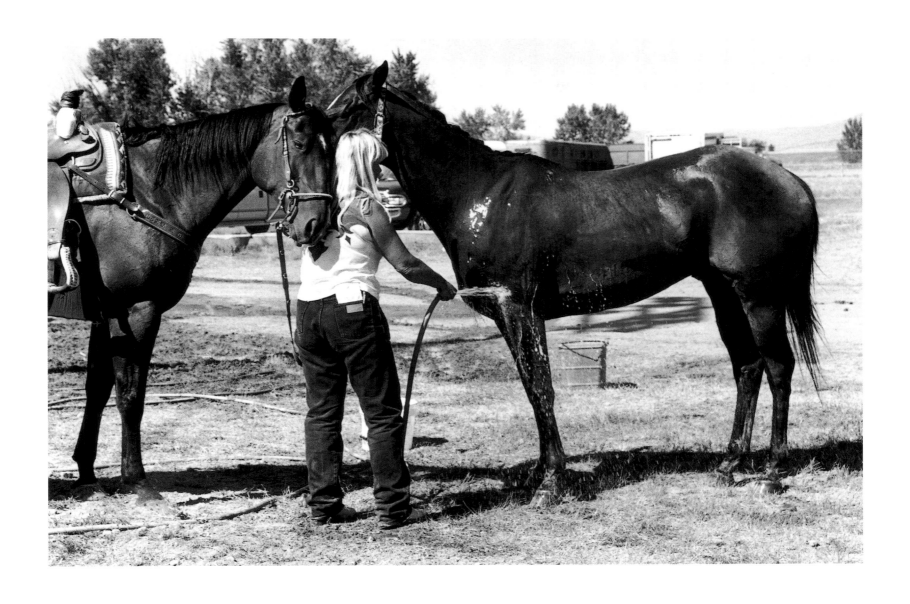

79. Hosing Down, Deer Lodge

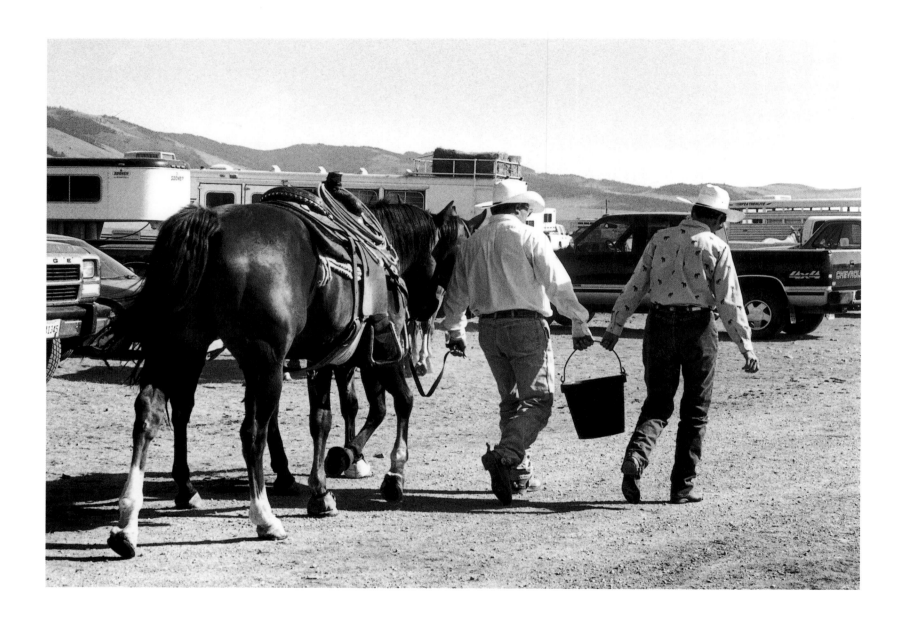

80. Watering the Horses, Wilsall

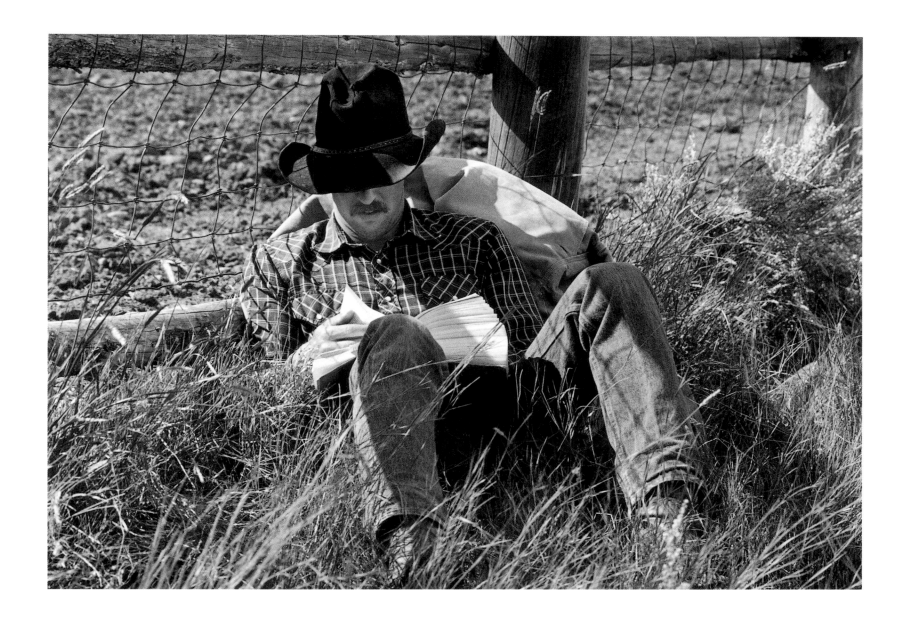

81. Breaktime, Wilsall

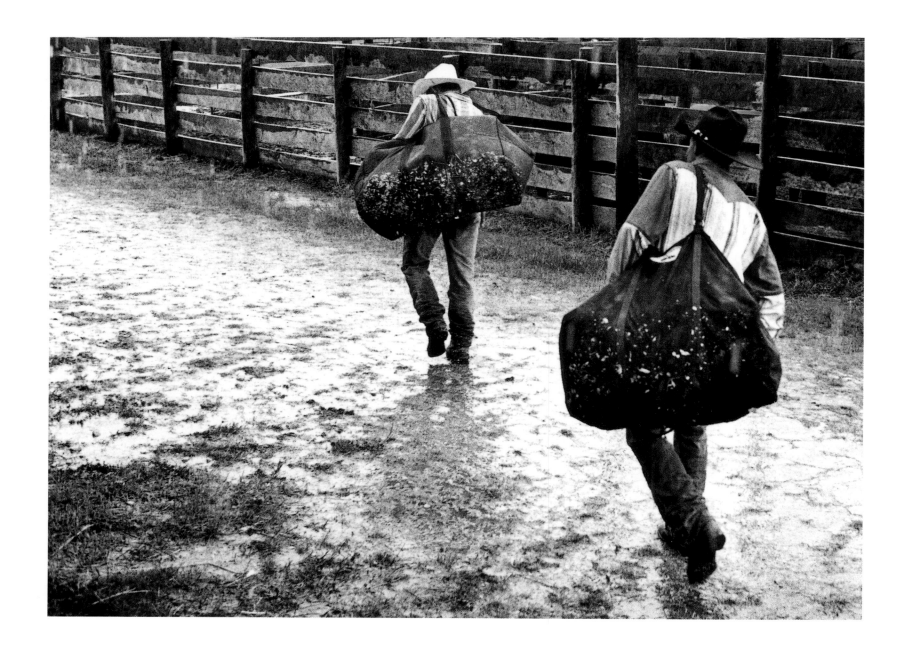

82. Cowboys with Their Gear Bags, Harlowton

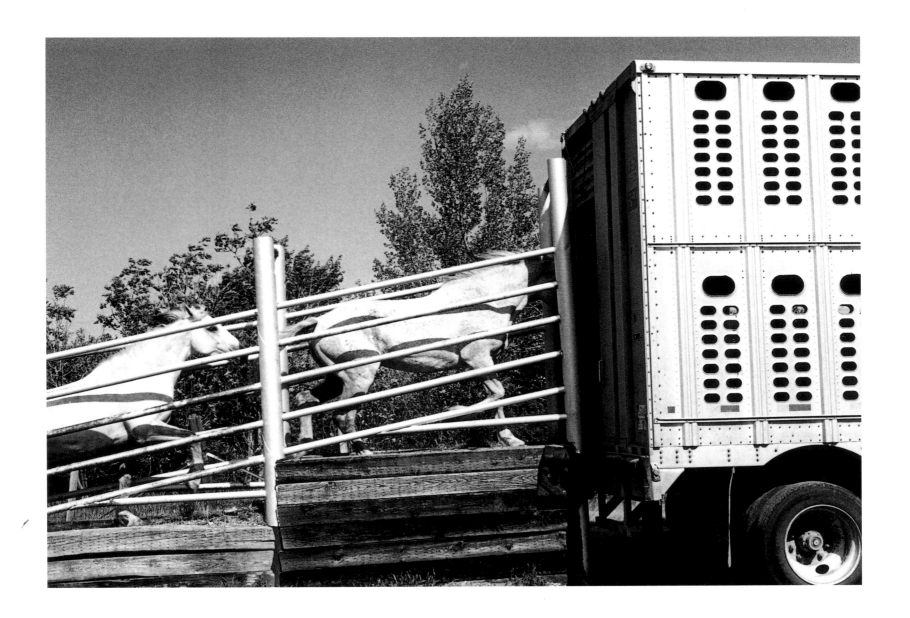

83. Loading into the Stock Trailer, Stanford

Photographic Credits

Plate 11. Young Cowgirl Practicing Roping, Townsend, 2001: CaDee Tew, Belgrade.

Plate 12. Young Cowboy, Boulder, 1994: Casey Carpenter, Kalispell.

Plate 13. Outhouse, White Sulphur Springs, 1997: Clay Witcher, Miles City.

Plate 17. The Crow's Nest, White Sulphur Springs, 1994: Tootie and Stan Rasmussen, Choteau.

Plate 19. Miss Rodeo Montana, Livingston, 2000: Mandy Holland, Dillon.

Plate 20. Lace Collar, Wilsall, 1995: Kathleen Cunningham, Emigrant.

Plate 27. Sheep Riding ("Mutton Busting"), Bozeman, 1990: Travis Wiley, Belgrade.

Plate 30. Cowboy, Augusta, 1994: Charlie Hahnkamp, Melrose.

Plate 40. Bareback Rider Hung Up in Rigging, Big Timber, 1993: Bob Schall, Arlee.

Plate 44. Cowboy with "Piggin" String for Tie-down Roping, Ingomar, 1995: Jay Hahnkamp, Melrose.

Plate 49. Team Roping, Logan's Ranch, Clyde Park, 1992: Jim and JimBo Logan, Clyde Park.

Plate 51. Breakaway Roper, Lewistown, 2000: Mary Salmond, Choteau.

Plate 52. Barrel Racer, Roundup, 2001: Jessica McFarland, Hamilton.

Plate 60. Bullfighter, White Sulphur Springs, 1996: Shawn Penrod, Miles City.

Plate 63. Bull Rider, White Sulphur Springs, 1998: Shawn Penrod, Miles City.

Plate 66. Bull "Ballet," Harlowton, 1993: Bull "Taco Time" owned by Rodney Newman; Scott Woodward, Three Forks.

Plate 67. Rodeo Clown Assisting Medics, Big Timber, 1994: Flint Rasmussen, Stevensville.

Plate 69. Waiting, Wilsall, 1992: L. Kerry Simac, Winifred; R. Phil Hastings, Bozeman.

Plate 72. Calf Roper, Three Forks, 1992: Bill Boyce, Lewistown.

Plate 73. Young Cowboy Receiving Belt Buckle Award, Lewistown, 2000: Nolan Descheemaeker and Slim Lemon, Lewistown.

Plate 74 Rodeo Clown and Friend, Wilsall, 1993: Julie Shoen, Dillon; Flint Rasmussen, Stevensville.

Plate 75. Gate Man, Harlowton, 1995: August Winsky, Harlowtown.

Plate 76. Bullfighter, Wilsall, 1993: Justin Hawks, Billings.

Plate 77. Cowboy Awarded Belt Buckle for Calf Roping, Ennis, 2000: Travis Caldwell, Billings; Pat Hamilton, Ennis.

Plate 78. Award for Thirty-Five Consecutive Years of Timing and Announcing at White Sulphur Springs Rodeo, 1997: Tootie and Stan Rasmussen, Choteau.